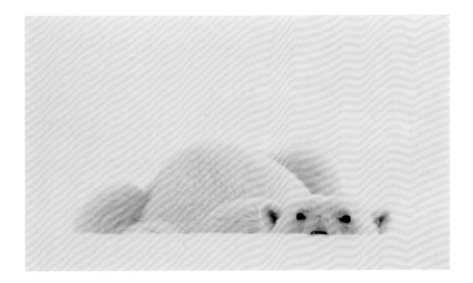

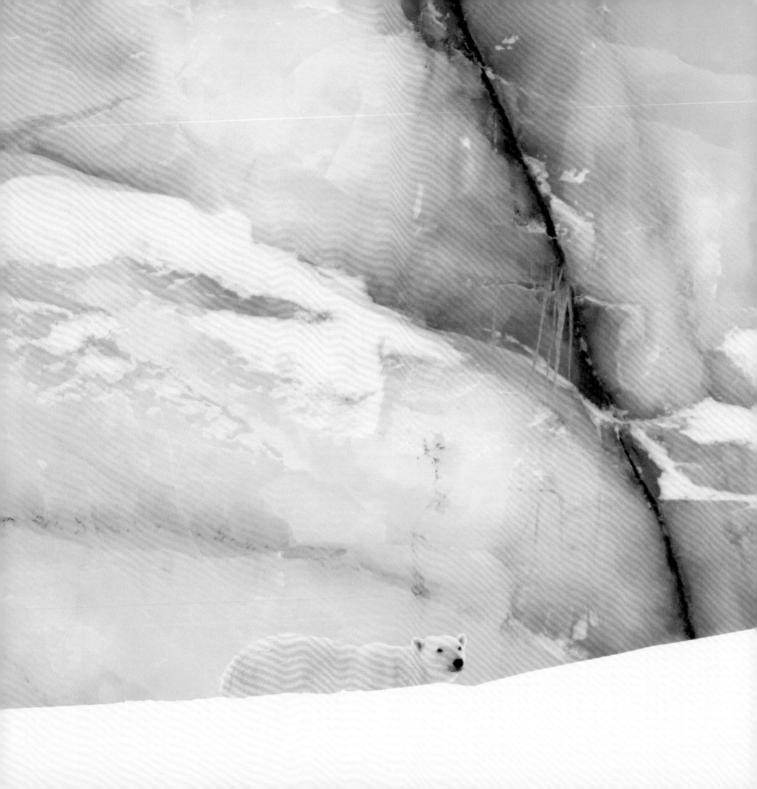

JOURNEY TO THE ARCTIC

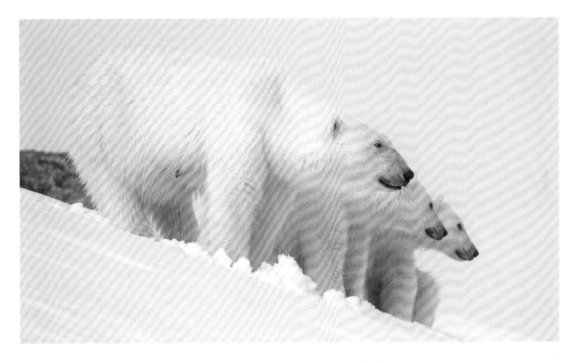

Photography by FLORIAN SCHULZ

Text by Florian Schulz & Emil Herrera-Schulz

COMPANION TO THE FILM *TO THE ARCTIC*

Preface by Greg MacGillivray

BRAIDED RIVER

WITH APPRECIATION FOR SUPPORT FROM CAMPION FOUNDATION AND MARGOT MacDOUGALL

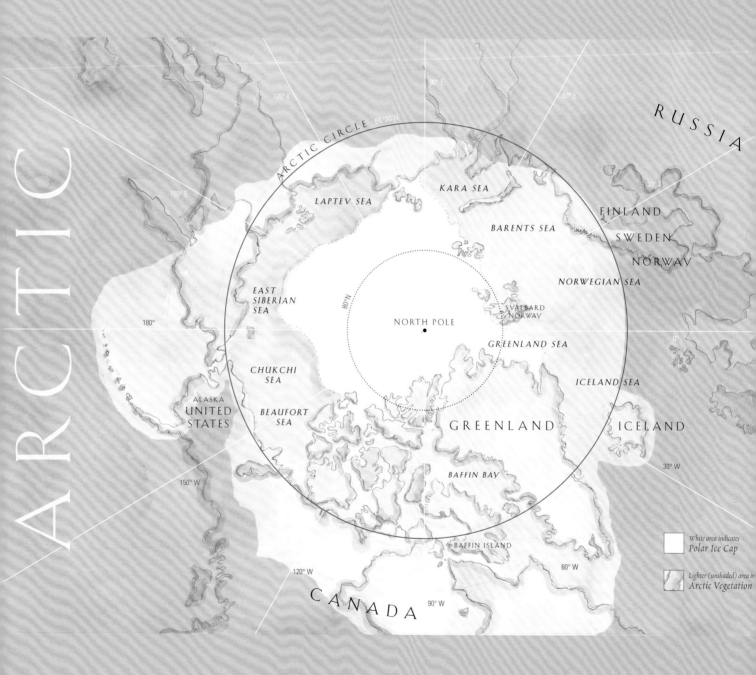

CONTENTS

POLAR BEARS

15

MUSK OXEN

31

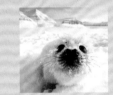

RINGED SEALS

43

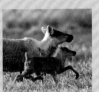

CARIBOU

53

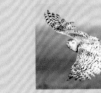

SNOWY OWLS

63

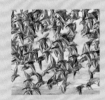

MIGRATING BIRDS

71

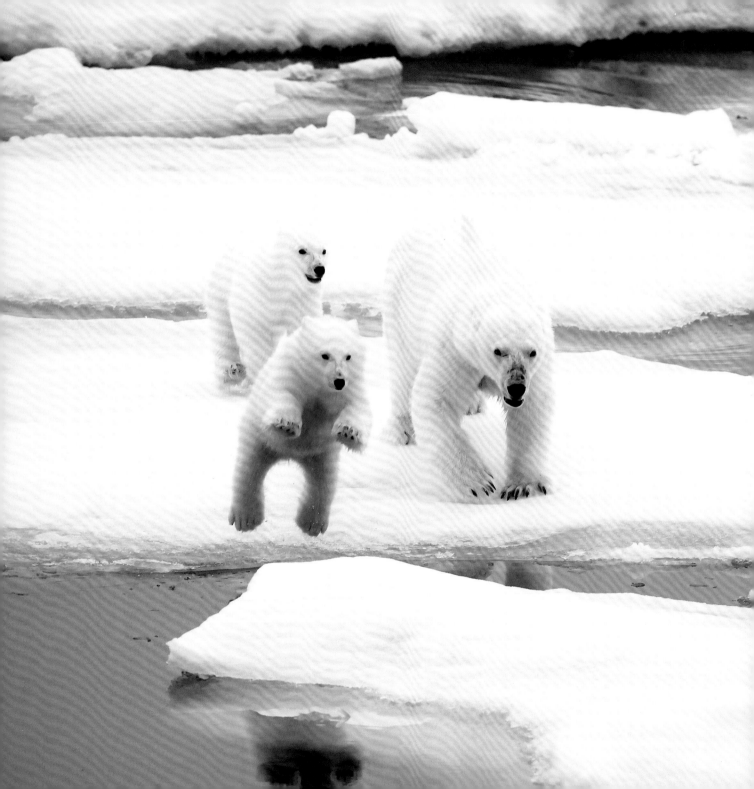

ARCTIC

In the far north, everything exists on a grand scale—the sky seems to stretch into eternity, the mountains, valleys, and ice fields make for landscapes and seascapes of outsized proportions. Over the course of four years, our journey to film one of the last truly wild and pristine landscapes on Earth had taken us to three countries in the circumpolar Arctic. It was during our travels that we also saw signs of the rapid warming of the arctic climate: in the change in

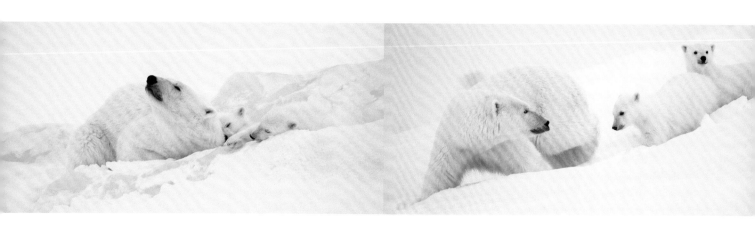

appearance of the land and ocean and ice, and in the behaviors of the wildlife being forced to adapt.

To capture the story of a place this vast on screen, we knew we had to tell the stories of the animal families uniquely adapted to life in this harsh environment. The cold and ice that we found inhospitable are the very reasons these creatures exist. After forty-five years producing films about remote and fascinating regions of the world, I knew if we could transport people to this special place with our film *To The Arctic*, we would have a great vehicle for motivating people to stop the damage—and even reverse some of it—before it's too late.

My son Shaun and I, along with our film crew, followed the migration of Alaska's Porcupine caribou herd as they crossed mountain passes to give birth to their young on the arctic coastal plain. One morning, we arose from our tents to find an immense herd flooding the tundra and filling the air with their grunts and hoofbeats. Quickly grabbing cameras, we were rewarded with some exciting close encounters as thousands of caribou flowed past us in an uninterrupted stream.

In Canada's Arctic, we dove into the subfreezing brine with our 400-pound submersible IMAX® camera through a hole bored in the four-foot-thick surface ice. Below the ice, we discovered a surprising world of red and yellow sea anemones haunted by the lumbering grace of whale sharks, diving polar bears, and curiously playful walruses. If our cameraman had stayed underwater for more than forty-five minutes, his hands would have frozen even with protective gear, yet animals and sea creatures thrived.

Nine degrees shy of the North Pole, we witnessed the incredible story of survival that would become the

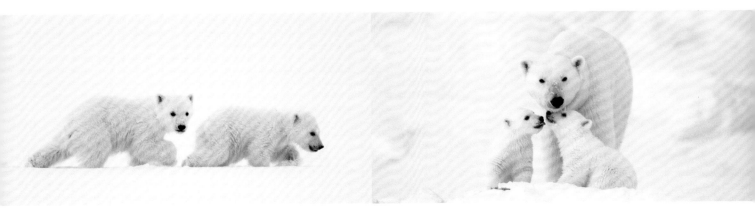

centerpiece of our film. Along with Florian Schulz, the photographer of the two companion books to our film, we observed a polar bear mother and her two young cubs from the deck of an icebreaker out of Svalbard, Norway. We watched as the cubs frolicked like puppies, batted ice chips around like hockey pucks, pounced on each other in mock attacks, and sweetly nursed.

Early one morning, as the polar bear family napped under the midnight sun, the sleepy mother lifted her muzzle to scan the air with her nasal radar. Suddenly she was up. Approaching fast was a male polar bear—very thin and looking hungry. At the sound of their mother's bark, the cubs awoke, leaping from the ice floe into the water. Snarling and snapping at the approaching male, the mother bear swam behind her cubs as they began what became a grueling four-mile swim. Finally, the male bear turned away,

ending the most thrilling chase I have ever captured on film.

For almost a week, this extraordinary mother polar bear allowed us to watch as she cared for and instructed her cubs. I was amazed and deeply moved by her tenacity. Everything she has to do to keep herself and her cubs alive is now much more difficult because of warming temperatures. She doesn't have as many months to hunt because her hunting grounds, the sea ice platforms, are melting earlier each year. And as the ice floes shrink, she and other polar bears must occupy a smaller location, meaning there's extra competition for territory and food. Yet she's completely committed to her cubs' well-being and safety. She never gives up.

I believe that I am not alone in wanting to do all we can to give this mother bear and her two cubs a future by caring about their arctic home. 〜

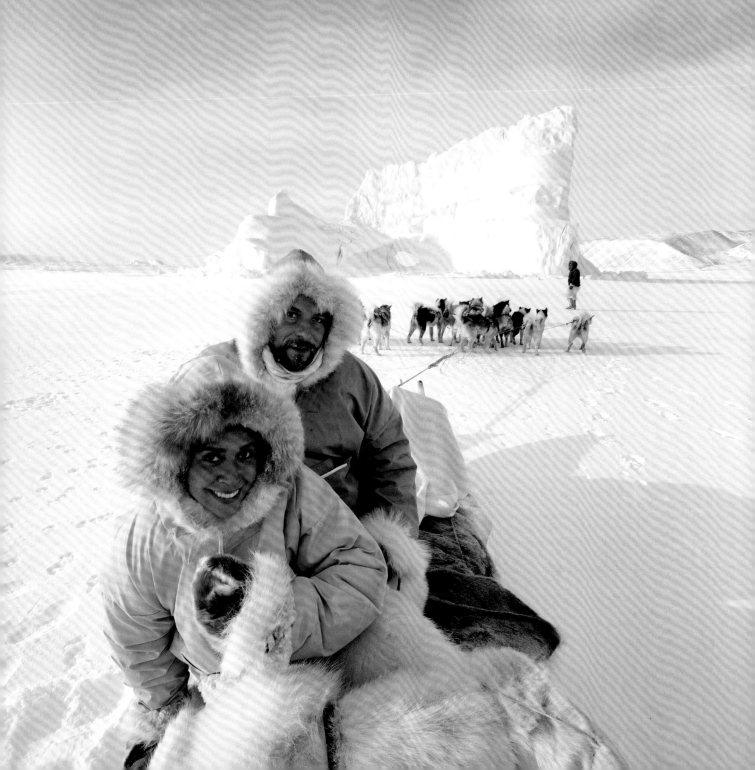

INTRODUCTION
BY FLORIAN SCHULZ

In the Arctic, the passing of each season moves in an arc from light to darkness. It is the cold itself that sustains life here.

Each spring, new life stirs as polar bear mothers leave their snowy dens with their new cubs in tow. They patrol the thinning ice looking for seals—their most nutritious food. Millions of birds from around the globe take to the air for their annual migration to reach their nesting grounds in the far north. Their arrival brings the tundra to life. No time is wasted:

the birds lay their eggs just as the snow disappears. Arctic foxes zigzag their territory, hoping to flush a bird and steal its eggs. During this season, the caribou are well on their way north, heading for the arctic plains to give birth to their young. Here there are fewer predators, and the lush, new vegetation is full of nutrients.

In summer, the sun never sets, and life explodes on the tundra and the wetlands along the arctic coast. The mosquitoes and abundant insect life that are a nuisance to caribou and other mammals are an essential food source for the millions of nesting birds. Their newborn chicks need to grow quickly to be able to fly soon. Along the vast arctic plains, hundreds of thousands of caribou partake in the longest migration of any land mammal, the thrum of their movement echoing for miles.

During the brief summer months, the ocean becomes increasingly ice free. Thick sea ice remains, but it is far from shore—the only ice that lasts through the summer, until freeze-up occurs again in fall. Walruses haul out on this ice, positioning themselves over the clam beds they rely on for food.

For as long as possible through the year, polar bears hunt for seals from ice platforms close to shore, until the annual ice melt. Soon the ice retreats so far out to sea that the bears need to move toward land. While many animals thrive during summer, for polar bears life gets harder. Once they are on land, they have to survive without seals, and food for them is scarce. Each year as the pack ice melts

sooner, the time for them between nourishing meals becomes longer and longer.

In autumn, cold nights change the green hues of the tundra to bright reds interwoven with the yellows of willows that grow along creek beds. Flocks of snow geese fly in formation over the tundra, migrating south. The cranes follow, their calls often heard long before the eye detects them. Millions of shorebirds join the migrating hordes, visiting wildlife refuges along the way. Caribou return south over the mountains, retreating from the advance of winter. Now only the year-round residents remain in the Arctic. Ptarmigan begin to flock together in groups and feed on willow leaves near the creeks.

The path of the sun drops closer and closer to the horizon, and soon it will be dark all day long. As snowstorms turn the landscape white, the fur on musk oxen, foxes, and bears grows thicker, and ptarmigan, arctic foxes, and arctic hares change their earthy colors to a snow white that blends in with the environment.

One animal thrives in the cold of winter—the polar bear. The bears rest at the edge of the Arctic Ocean, awaiting the advancing sea ice so they can hunt for seals once again. When the snow is deep enough, pregnant polar bear mothers will dig their maternity dens, where they will give birth to their cubs. In the spring they will emerge with their young to hunt on the ice, and the ancient cycle that depends on the deep cold will continue.

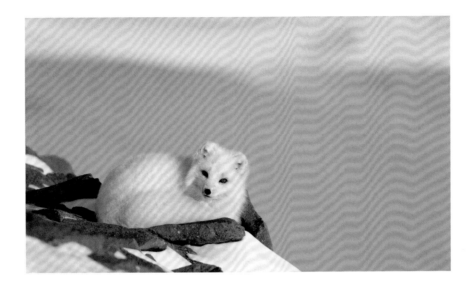

Over the course of six years, I have traveled the Arctic, journeying more than 2,500 miles. I visited Inuit communities from Point Hope, Alaska, to Qaanaaq, Greenland; dived and snorkeled in the Arctic Ocean; spent countless hours photographing from airplanes; and rafted down arctic rivers. With my wife, Emil, I traveled by snowmobile and dogsled with Inuit guides and their sled dogs. We accompanied the MacGillivray Freeman film team, including an expedition on an ice-going vessel in the middle of drifting pack ice while they filmed *To The Arctic* and I worked on two companion books for the film.

With the photographs of arctic mammals and birds in *Journey to the Arctic*, I hope to give you a glimpse into the inconceivable diversity and beauty of this part of our planet. If a certain image makes you pause, perhaps you will let your imagination take you to this mysterious, faraway place that these magnificent creatures call home. Maybe you will fall in love with the Arctic, as I have.

As my wife and I now marvel in our newborn son, we hope you may also sense what is on our minds: that underlying each image is a certain urgency—to look, to reflect, and to want to take care of this spectacular place. ᐧᐤ

▲ An arctic fox in winter. Svalbard, Norway.

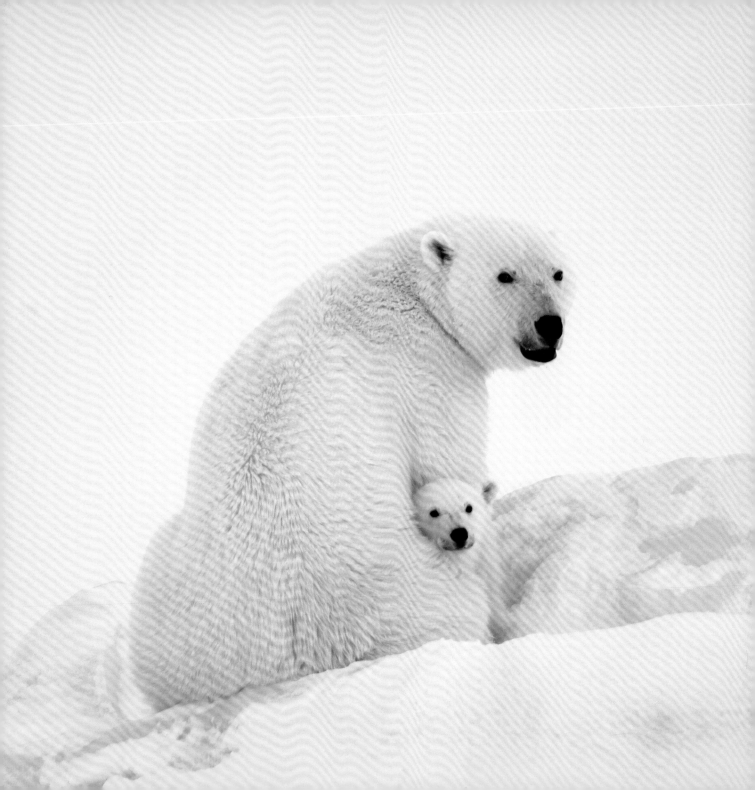

POLAR BEARS

BY FLORIAN SCHULZ & EMIL HERRERA-SCHULZ

FS: It is the end of spring in Svalbard, Norway—Europe's largest wilderness located only about 600 miles from the North Pole. Steep mountains and thick glaciers surround us. Towering walls of ice define the coastline and lead north as far as the eye can see.

The MacGillivray Freeman film team joined Emil and me, and we sailed north along the western edge of this high-arctic archipelago in search of polar bears. Our destination is a small bay, Holmiabukta, where a

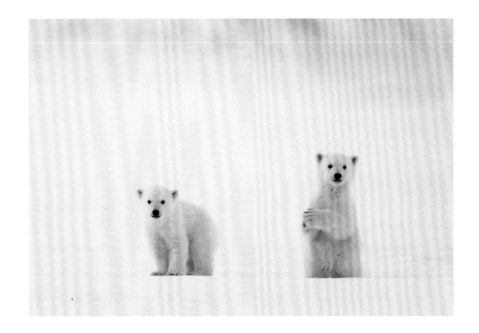

dead fin whale washed up on shore the previous year and fed many polar bears throughout the summer.

At the end of the bay, a glacier extends down to the water. We anchor our sailboat in the center of the bay. As the tide ebbs, the clean white spine bones of the enormous fin whale appear. We see a female polar bear resting with her cub near a large boulder on the far shore. When the tide is at its lowest, she enters the water through a small opening in the ice around the carcass. The remaining meat is below the surface, and she dives for it. The little cub stands but is reluctant to follow, and watches from shore.

The polar bear, the world's largest land carnivore and king of the arctic landscape, has an extensive range around the North Pole, and depends on the pack ice for its livelihood. From the ice, the great white bears can feed on the fat and rich nutrients of their preferred food, seals, which live on and below the pack ice. I have come to appreciate the scientific name of these bears—*Ursus maritimas*, sea bear—that are at home in this frozen ocean environment.

EH-S: We have been at anchor for ten days now, and I can recognize the different female bears with cubs that

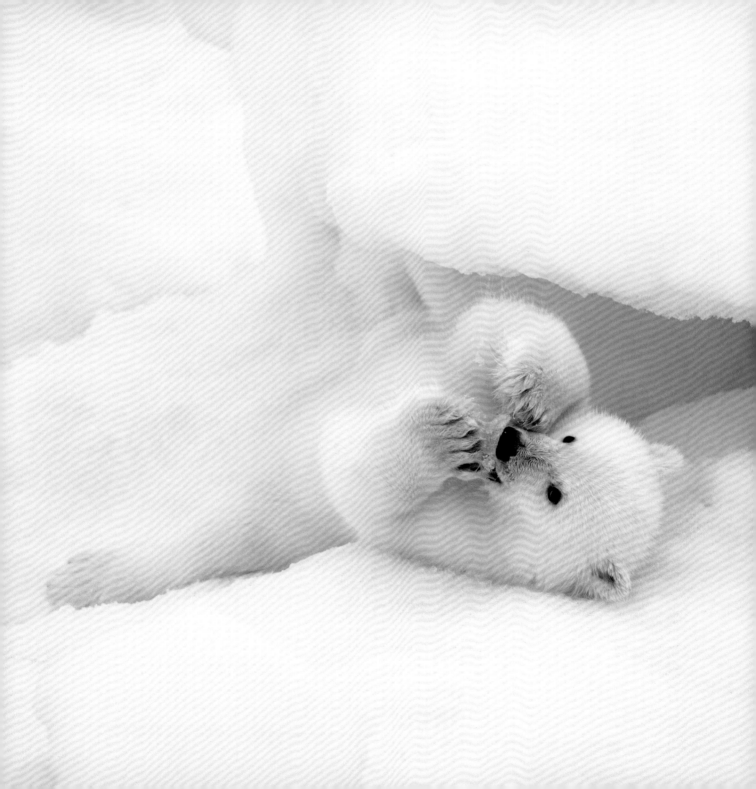

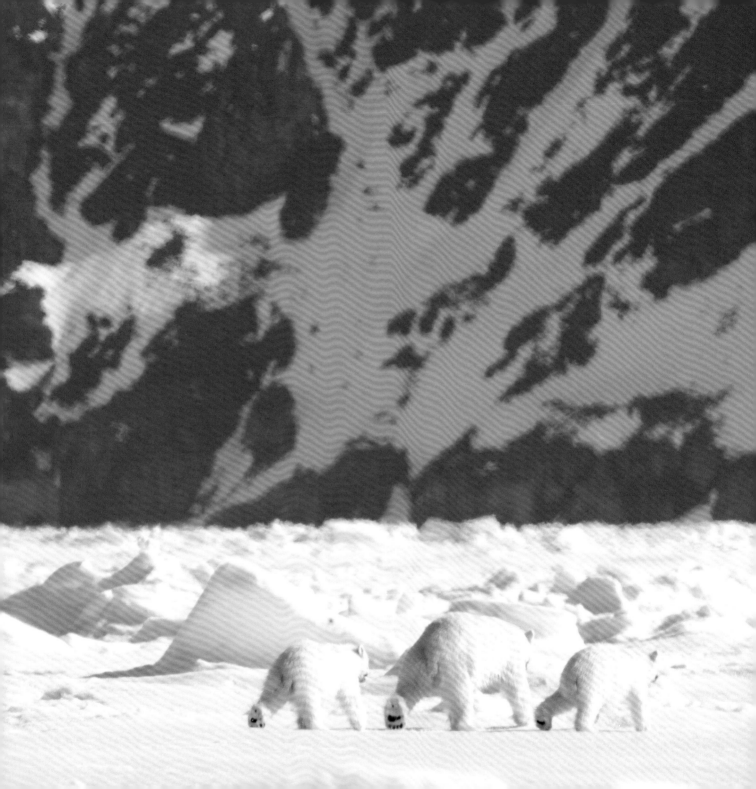

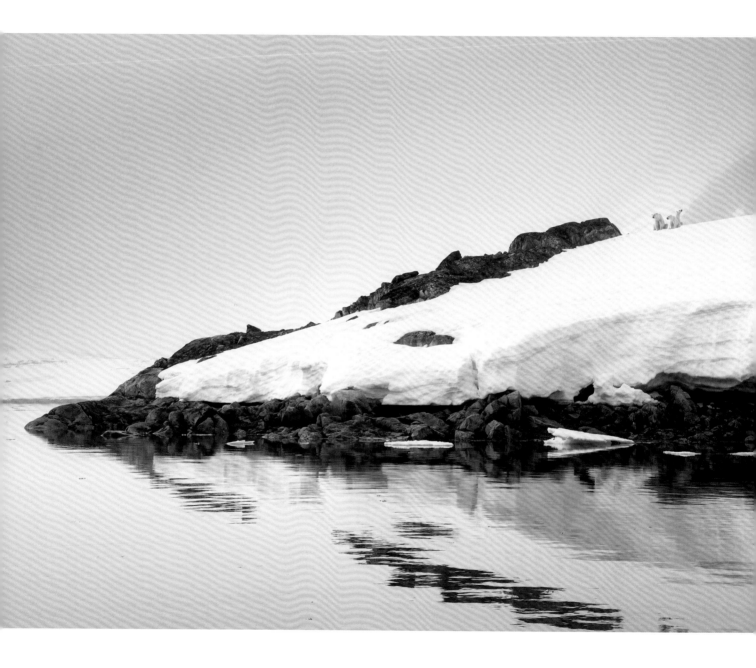

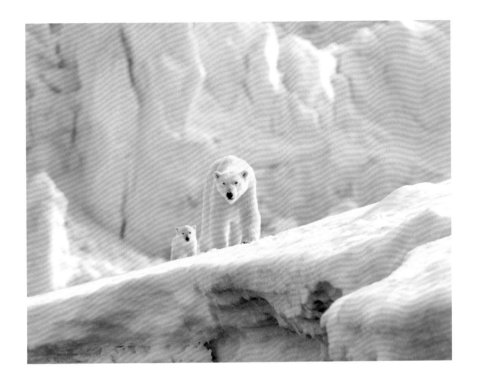

visit and feed on the whale carcass. This morning, a dense gray fog fills the air, and drift ice blocks our way to shore. We jump in our Zodiac craft, and paddle toward the shore. The silence is so deep we can hear the drips from our paddle as they hit the surface of the water. With binoculars tight against my eyes, I follow a mother bear as her heavy paws crush the ice. She stops abruptly, and from between her thick legs, a fuzzy little cub peeks out. The mother bear notices a huge male feeding on top of the whale carcass,

only a few yards ahead. Male polar bears, which can be twice the size of females, are known to kill cubs. With head down and ears pinned back, she comes face-to-face with the bear and confronts him with a deep roar. Protecting her cub is paramount. The male moves back a few steps, and then bolts when the determined female charges him.

I hear Florian whisper excitedly behind me, "Where is my wide-angle lens?" From over the ridgeline, a healthy mother bear with two chubby cubs arrives and pauses to

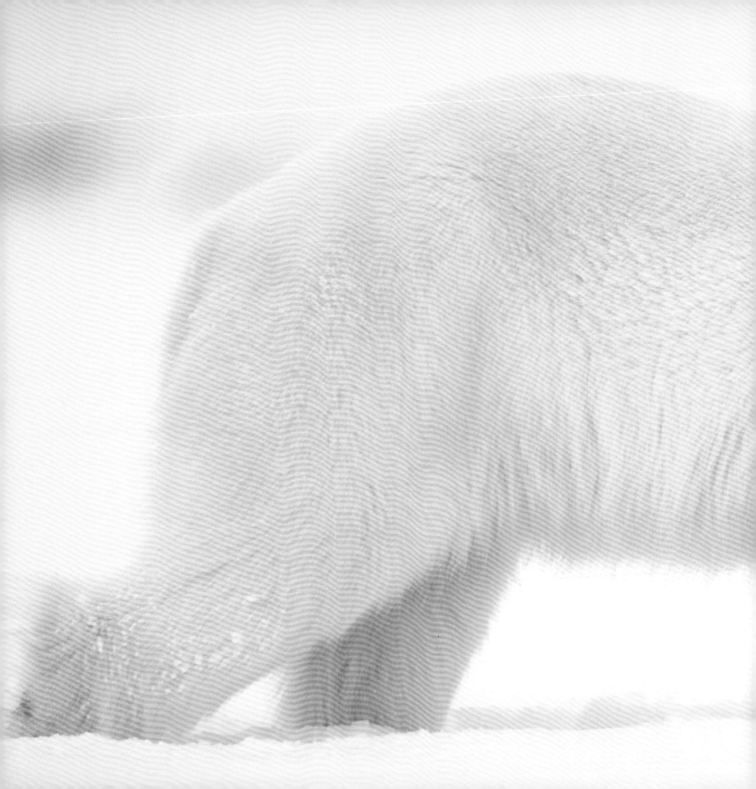

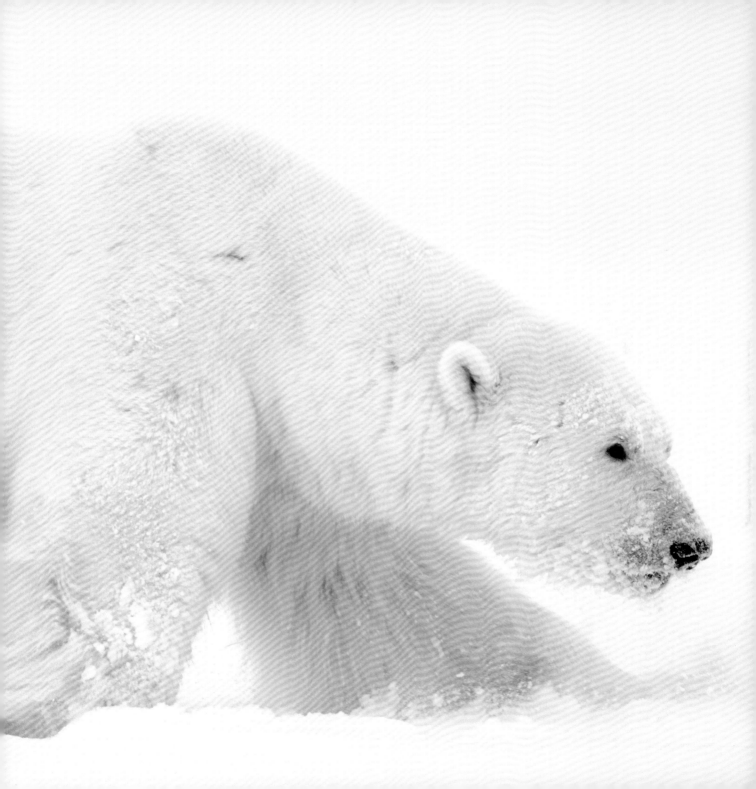

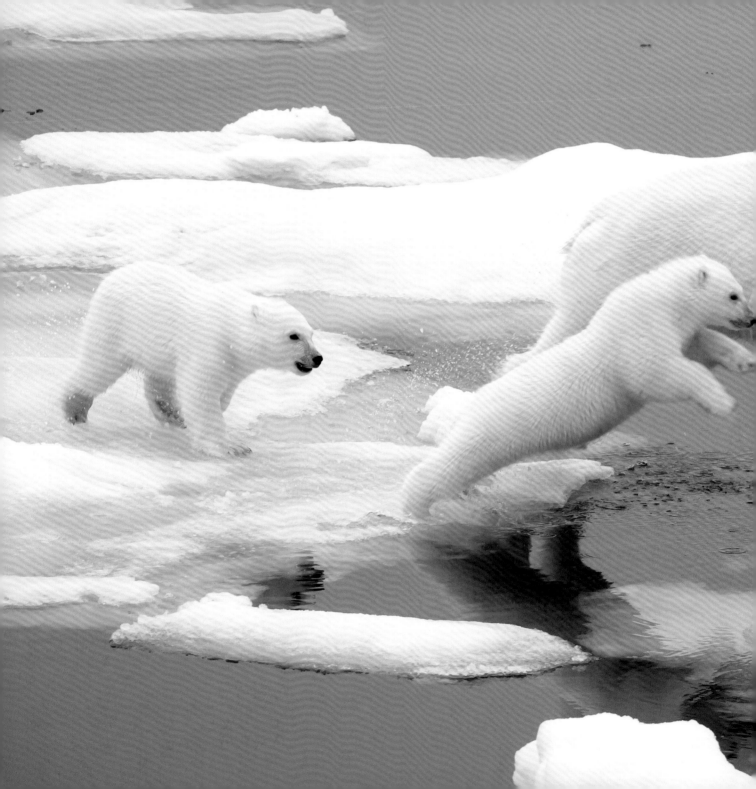

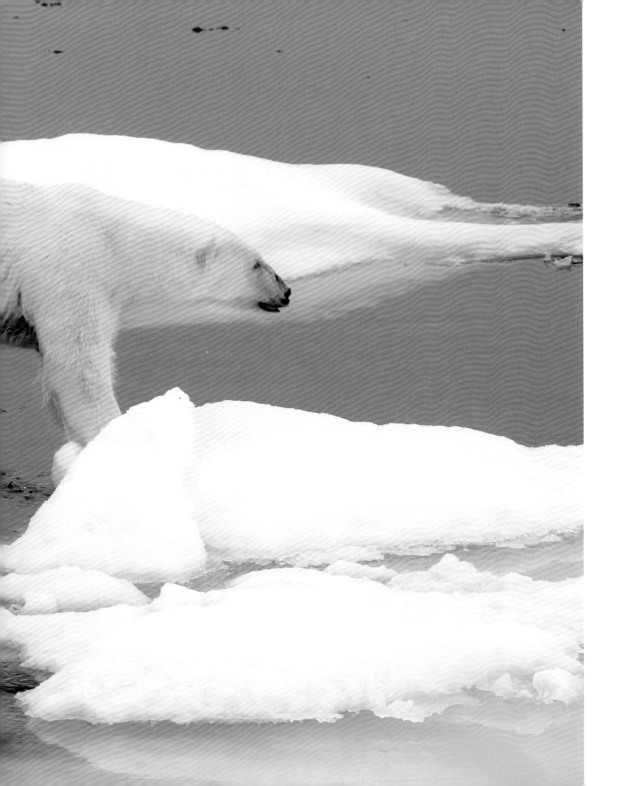

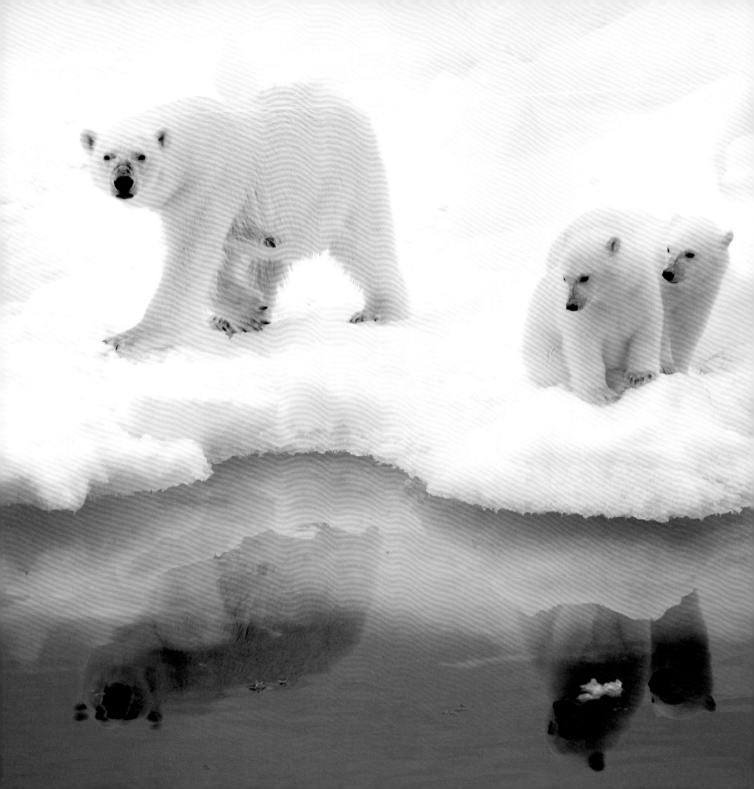

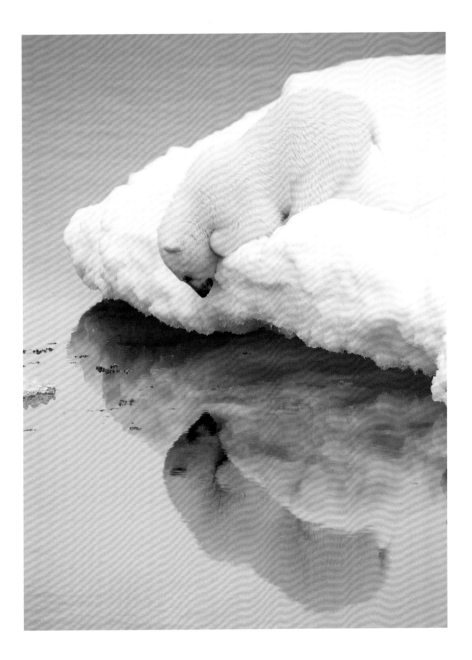

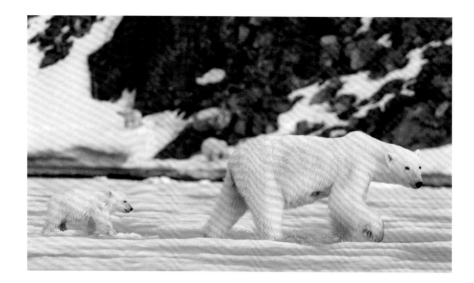

look around. As Florian captures a panoramic view of the bears in their environment, I reach for the video camera and start shooting the scene. Florian whispers directions about where to point the Zodiac. The mother polar bear and her cubs walk down the ridgeline toward the drifting ice. Florian is in my viewfinder as they enter the frame. The sun faintly tints the fog a pastel violet as the family walks along the edge of the drift ice, toward our Zodiac. Stopping abruptly, the mother looks ahead. We turn to look in that direction and see two large males play-fighting close by. She is not going to chance a confrontation. With her two cubs, she retreats to the other side of the hill to wait for the males to leave. Now at a safe distance, we watch as

the mother and her cubs roll in the snow to clean their fluffy fur and take a short nap.

This female bear's body is much rounder and larger than the other females we have seen around the carcass. Her fur is fluffier and cleaner, and her first-year cubs are bigger. They may have come from the pack ice, where there is plenty of food. With a rapidly warming environment, many bears are trapped on this island for the season, unable to get out to the pack ice to hunt for seals. To find a real meal here is a big challenge. Without the whale carcass, the bears would have to find other sources of food, like birds' eggs, seabirds, fish, even any available berries or grasses, until the ocean freezes again. ⌒

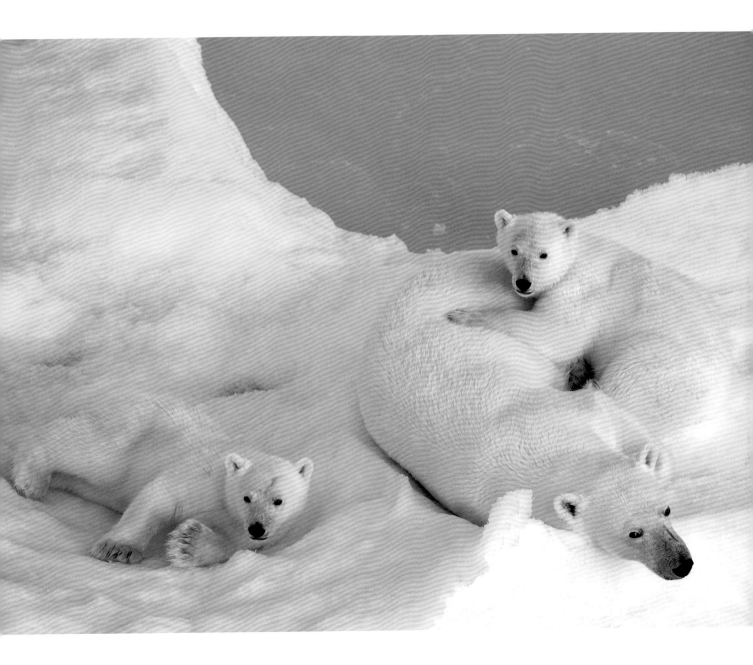

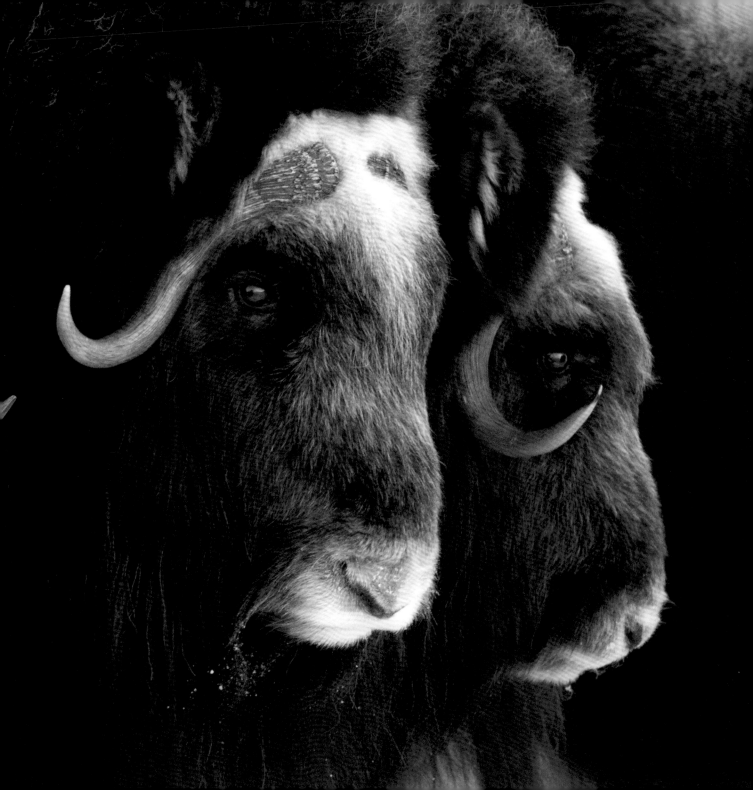

MUSK OXEN

BY FLORIAN SCHULZ

It is still dark when I leave my tent and the weather outside is well below freezing, but I am eager to find the musk oxen before the sun breaks over the horizon. I have spent many hours over the past few days watching these intriguing animals as they wait out the winter. With long fur coats and heavy, curled horns, they look prehistoric, like creatures from a fairy tale.

When the days get shorter and the arctic winter approaches, birds and caribou migrate south, and

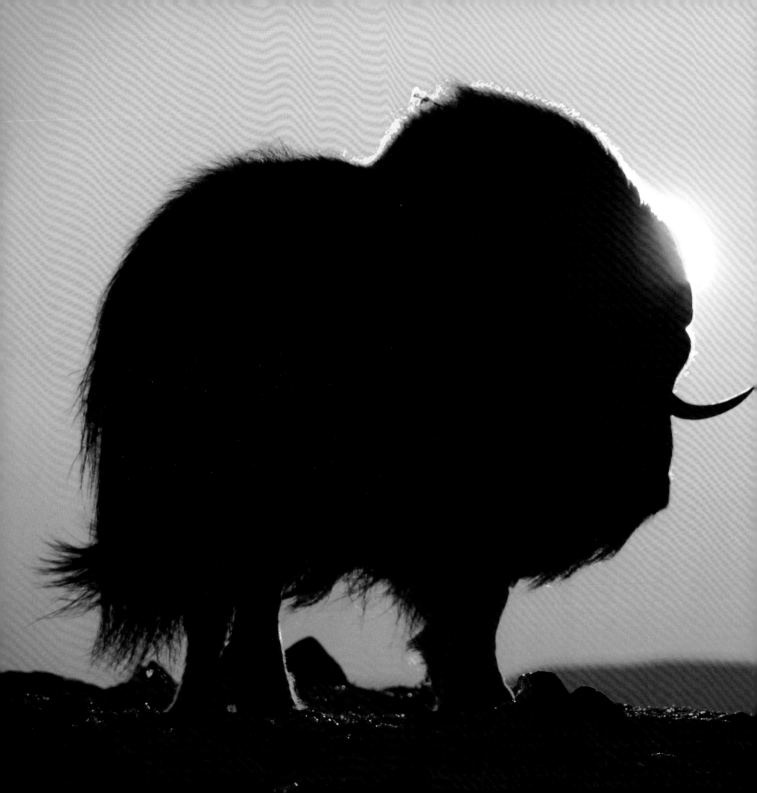

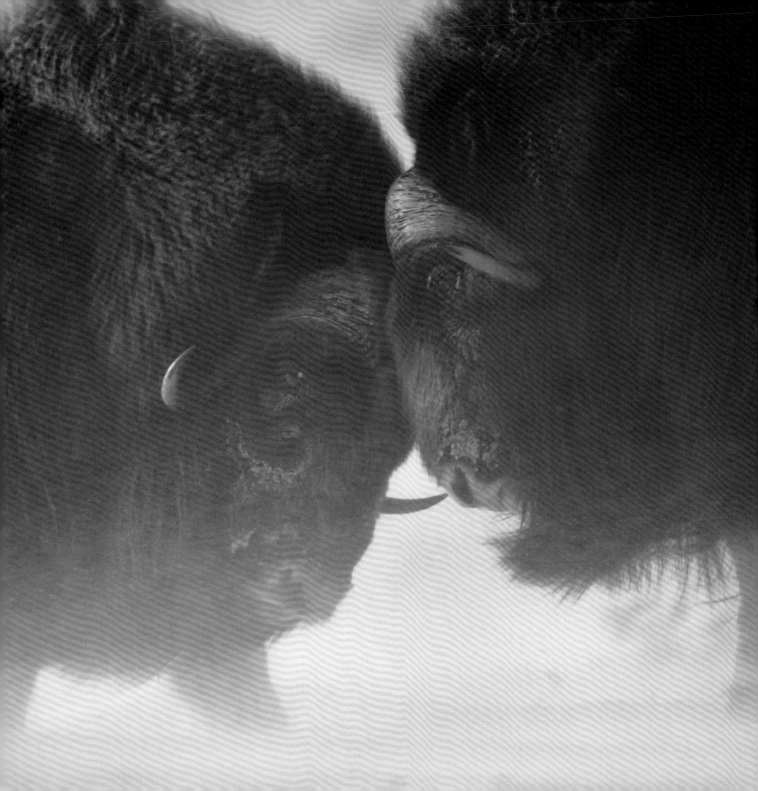

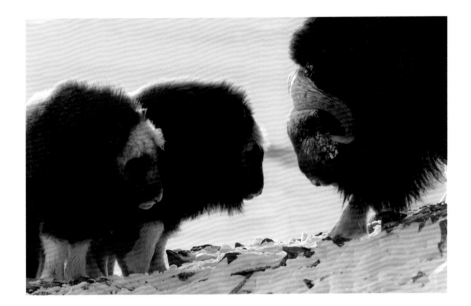

polar bears venture back out onto the sea ice. The tundra is blanketed in snow, and for many miles no life can be seen. Few animals are adapted to live in the Arctic year-round, but the musk ox is one of them. With its long guard hairs and woolly undercoat that is eight times warmer than the highest quality sheep's wool, a musk ox can withstand even the harshest arctic conditions.

I am wrapped in several layers of polar fleece and outer garments, but at 20 degrees below zero, my face is beginning to feel numb and my hands are stiff and struggling to manage my camera. The stars are fading in the predawn light as I make my way to the place where I had watched the musk ox herd the day before. Resting my telephoto lens on the frozen rocks in front of me, I had watched as a big musk ox bull gathered his herd into a tight group, eyeing me curiously as I lay on my stomach on the packed snow. I could smell the bulls' musky odor, which gives these creatures their name. I discovered that if I stayed close to the ground, the musk oxen didn't seem to mind my presence.

With their sturdy bodies and weighty horns, musk oxen aren't built for speed, so I think they must not have gone far. I also know that they have to conserve their energy in the winter. Even when threatened, musk oxen

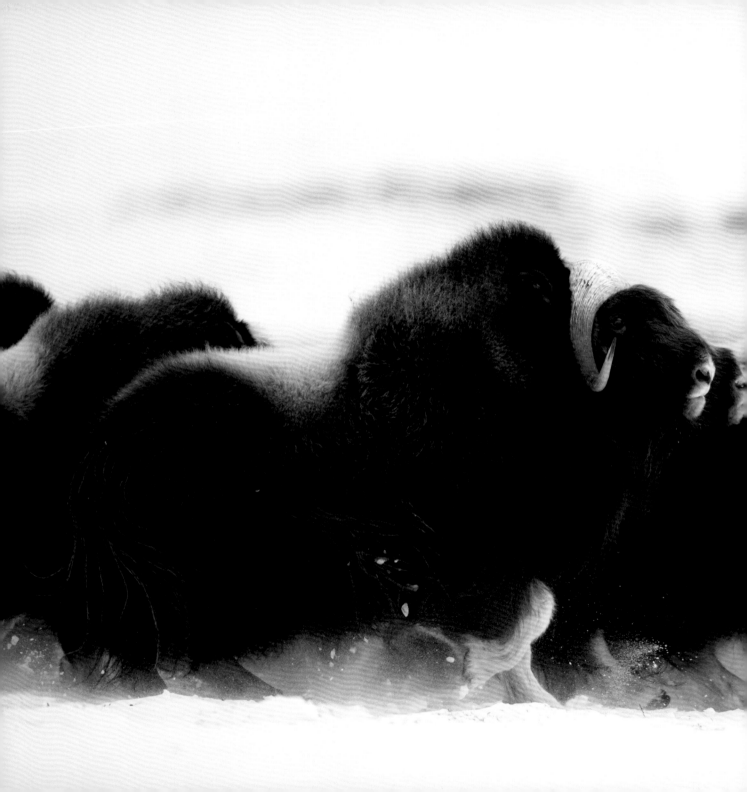

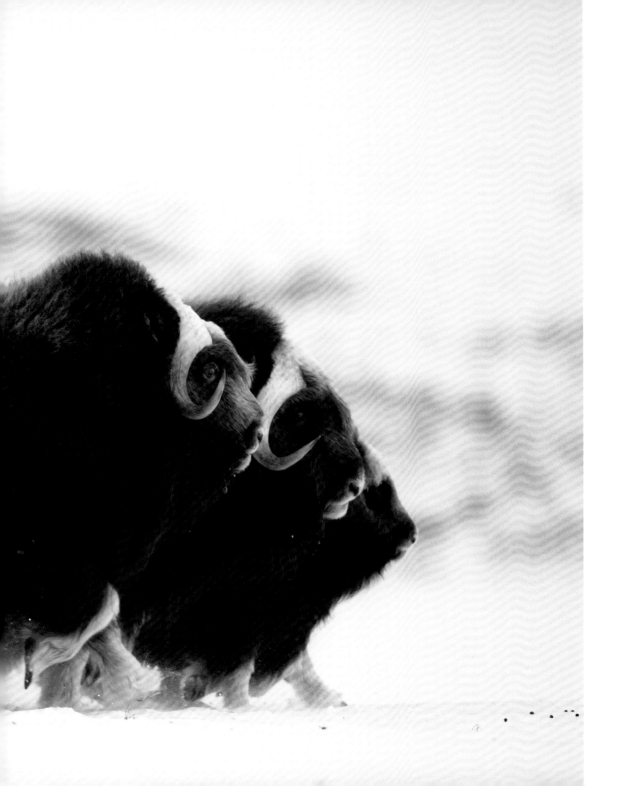

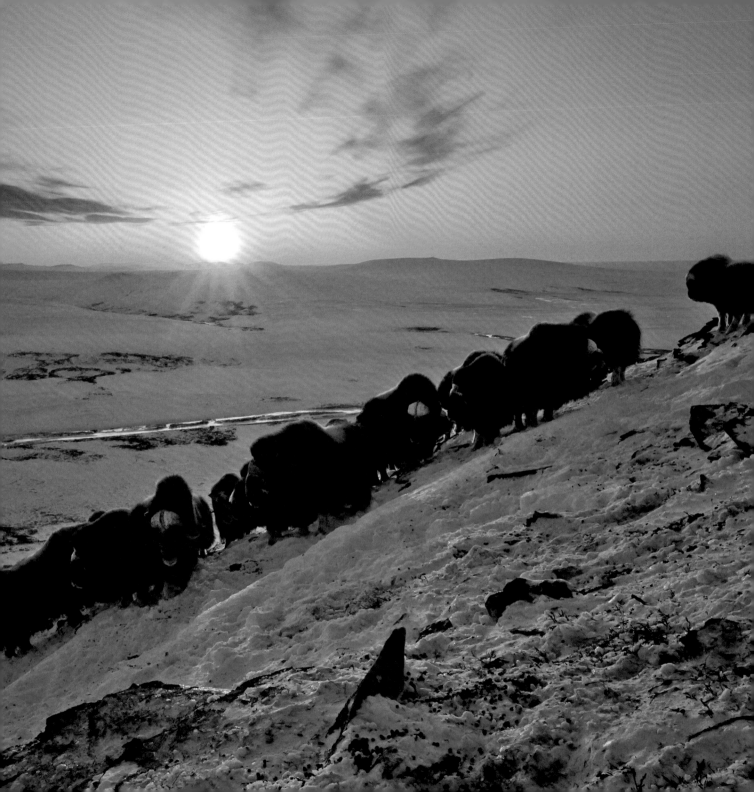

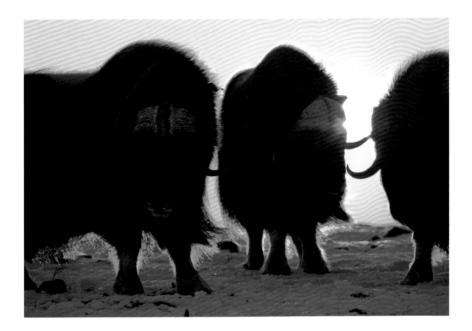

don't run from danger, but form a circle around their calves, their horns facing out for protection.

Now, as I return to my post, I am surprised to see only blank, white tundra where the musk ox herd stood. I search the surrounding hilltops with my binoculars, but can't see a single animal. As the northeast horizon is beginning to glow orange, I worry that I won't find the herd by the time the sun comes up.

To get a better view of the surrounding landscape, I climb toward the top of the nearest hill. When I reach the ridge, I discover the herd standing on the steep slope below me. The wind is blasting this side of the hill at 40 miles per hour, but the musk oxen are intent on their task.

I watch as they kick with their large hooves, sending clouds of snow blowing into the wind. Now I understand why they moved to the exposed side of the mountain. Here, the wind blows the snow away from the ground, leaving only a few inches covering the lichen below. It is a marvel that these large creatures can live through the long arctic winter, feeding only on bits of frozen lichen.

As the musk oxen find their breakfast below the snow, I take out my wide-angle lens and frame the whole herd.

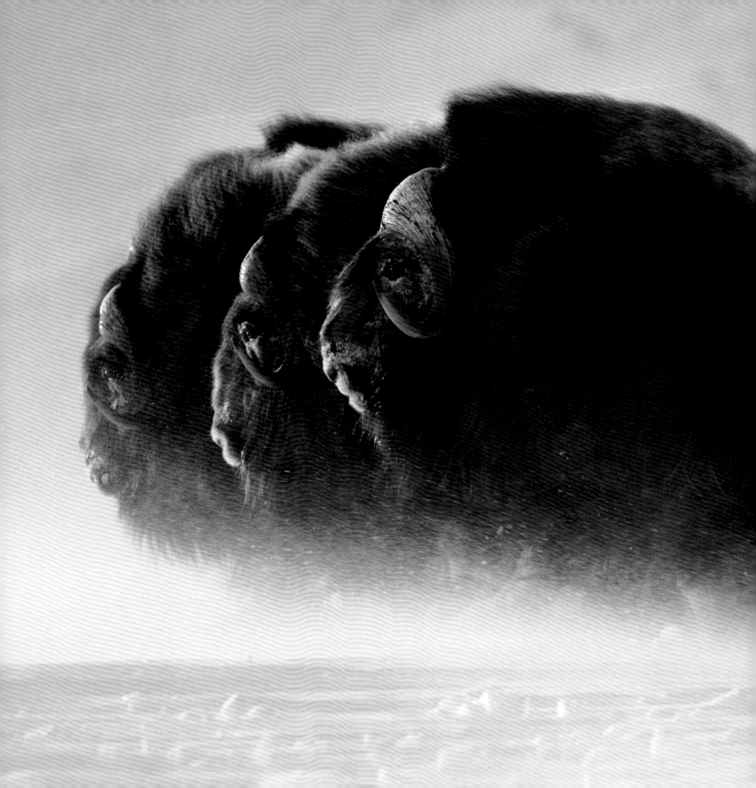

The sunrise fills the clear sky, painting the surrounding hills golden as I begin to photograph. This scene is exactly what I had hoped to find when I left the warmth of my sleeping bag before dawn. During late winter in the Arctic, most of the daylight looks like dawn or dusk, the sun hovering over the horizon for only a few hours before sinking, plunging the icy landscape into another long arctic night.

The next day, I plan to photograph the musk oxen as the sun is setting. This time, I have no trouble finding the herd. They have returned from the steep side of the mountain, somehow satisfied by their meager lichen meal the day before. The sky is clear, but the wind has picked up overnight, blowing snow through the air. As I walk toward the herd, they look like shadows behind dense fog. The thick layer of snow blowing around their feet makes it seem like they are floating on air.

Ice crystals whip my face, stinging like grains of sand. Even in the bitter cold, I am excited by the way the wind is transforming the landscape. In my years of traveling the Arctic, I have seen weather like this many times. Through my photographs, I always try to show the real arctic world—a place that is always fascinating and beautiful, but also harsh and unpredictable.

The musk oxen don't seem to notice the wind at all. They must withstand these conditions throughout the winter. As I photograph a group of bulls, I can't help wishing for a musk ox's warm coat to protect me through the storm. ⌒

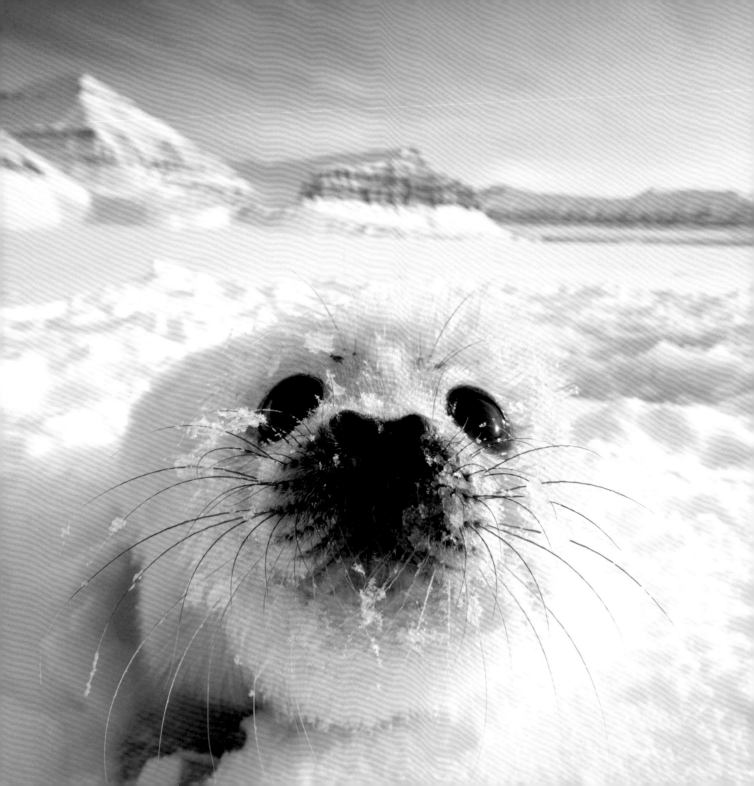

RINGED SEALS

BY FLORIAN SCHULZ & EMIL HERRERA-SCHULZ

EH-S: With binoculars, I scan the frozen fjord for little bundles of fur scattered across the smooth ice. Seal pups are usually hidden in snow lairs atop the sea ice while their mothers hunt below, but this year the snow layer is unusually thin in western Svalbard, Norway, and the ringed seal pups lie exposed on the ice.

As my eyes lock onto the fluffy white seal pups, I think about how vulnerable they are. A baby seal lying on the ice would make an easy snack for a

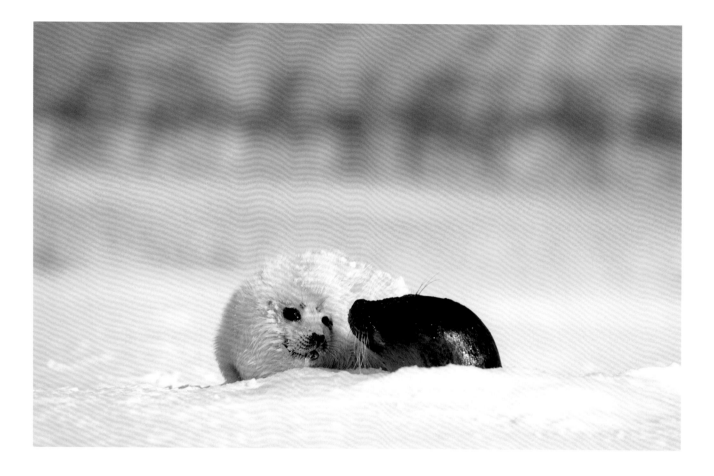

hungry polar bear. It's late winter in the Arctic, a time when most animals have long since migrated south or are dormant until the warmer weather arrives. For animals that rely on the ice, like ringed seals and polar bears, late winter is the most active time of the year.

Seal mothers haul out and give birth to their young on the surface of the ice. Until the pups are strong enough to swim in the cold water, the mothers dive through holes in the ice to hunt, returning to the surface to nurse their babies and watch for predators.

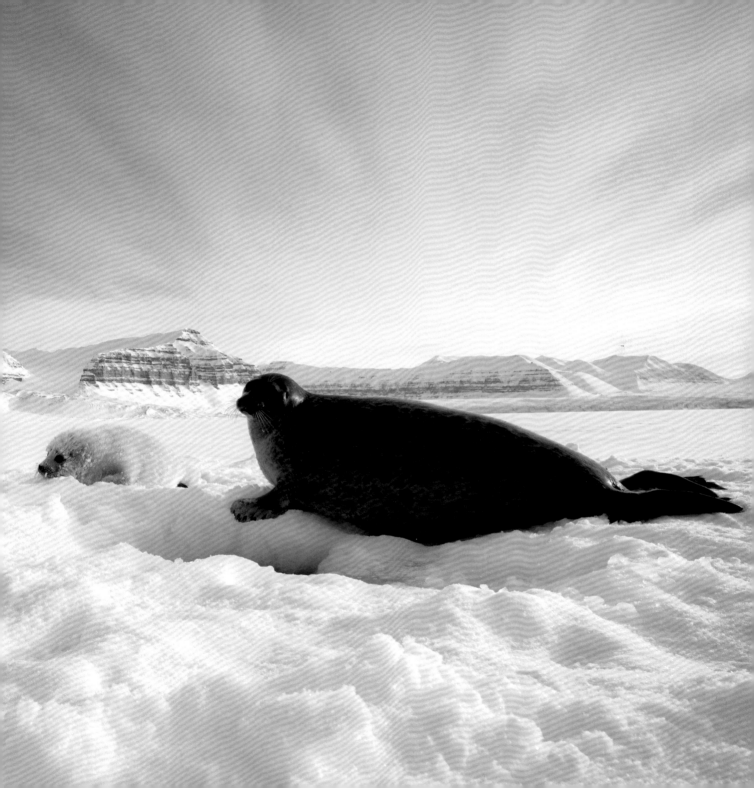

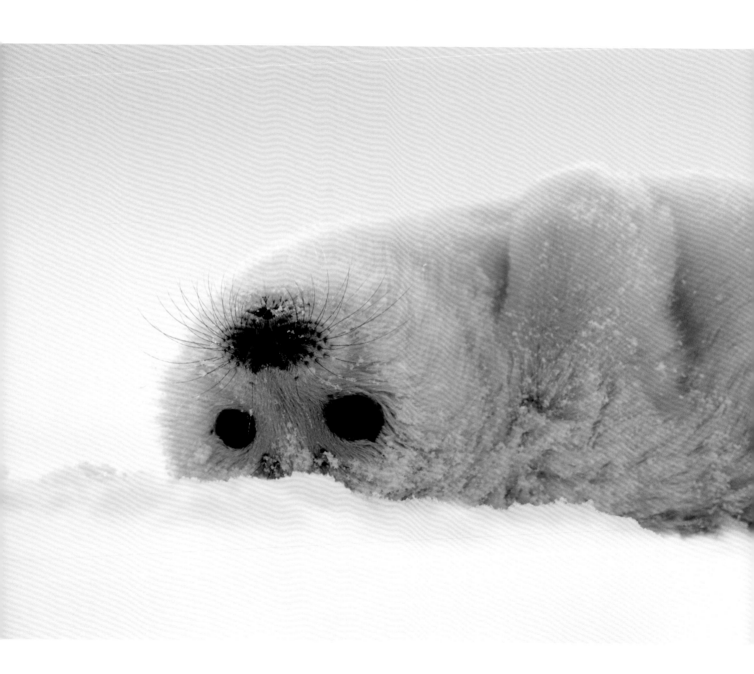

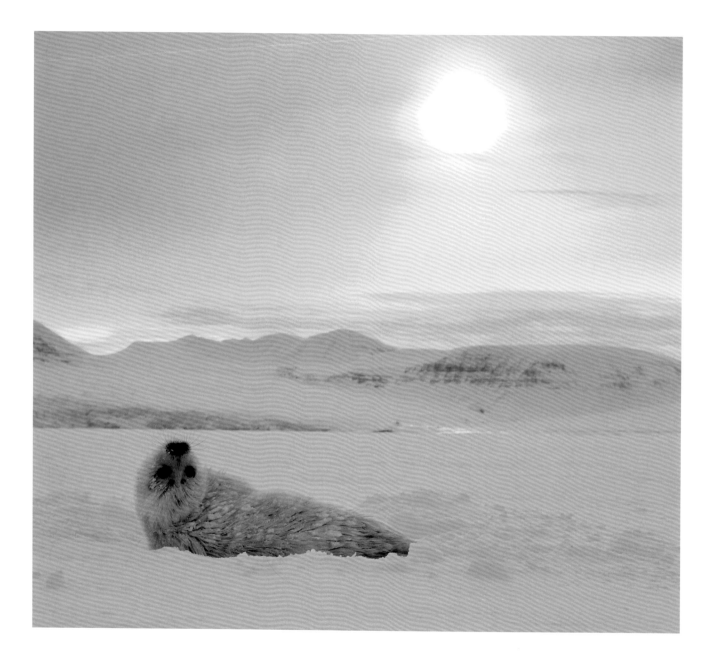

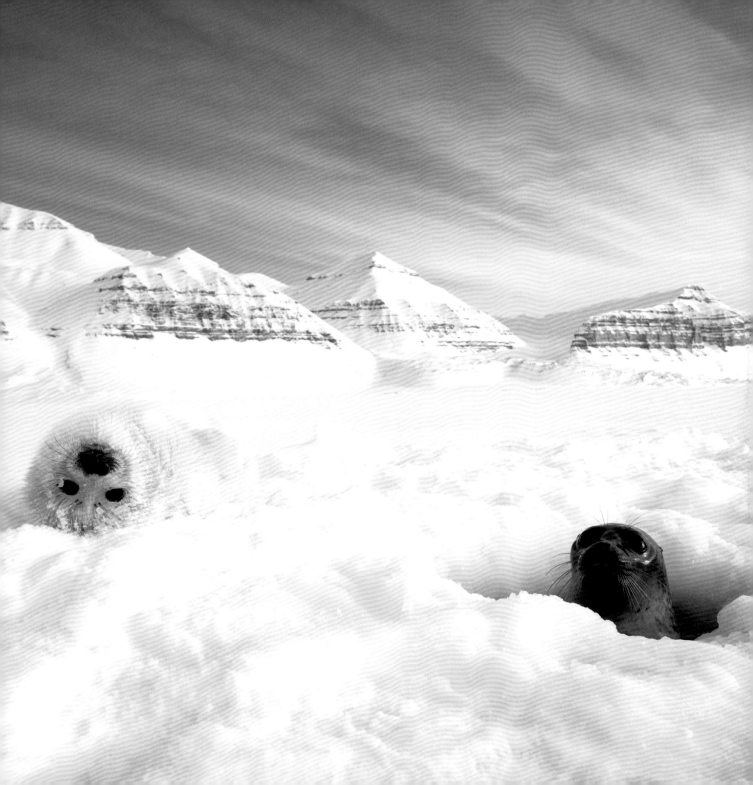

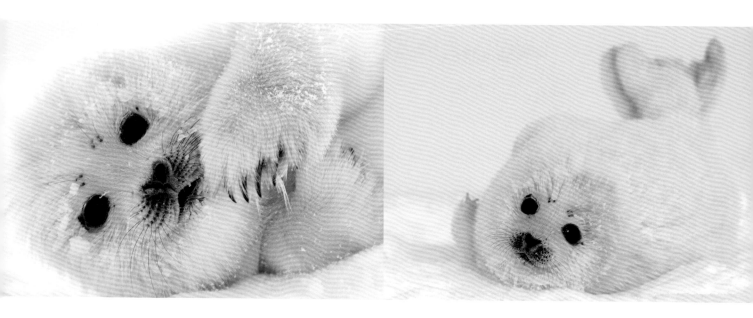

Traveling farther into the fjord, we can see the gray heads of attentive mother seals popping up through the ice holes next to their pups, and we hear the pups calling to their mothers, *juoeoeoeoe, juoeoeoeoe.*

FS: With a splash, a mother seal surfaces next to her pup. I lie as still as I can on the ice, hoping that I look like another seal in my dark parka. I don't even dare move my finger to take a picture. After scanning the ice around her, she disappears once again into the dark water.

I have been lying on my stomach for hours, inching closer to the two-foot-deep hole in the ice where the seal pup waits for its mother. I'm so close now I hardly dare to breathe, watching through my viewfinder as the pup rolls on its back in the snow, stretching and testing out its claws.

Pausing, the pup calls out urgently, just as I hear a sound like steps breaking through the snow behind me. *Kchuak kchuak kchuak.* A wave of fear flashes through my body. It cannot be my guide; I would have heard the snowmobile if he had come back. Reaching for my flare gun, I check to make sure the trigger is not frozen. Slowly I turn my head, expecting to see a hungry polar bear crossing the fjord in search of dinner.

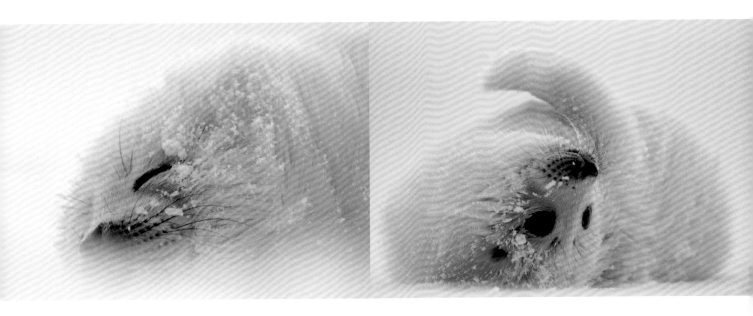

To my relief, there is nothing behind me but open snow and massive glacier walls rising in the distance. *Kchuak kchuak kchuak.* I hear the sound again, but this time it seems to be coming from below the surface of the ice. Smiling, I realize I am hearing the mother seal scraping a hole in the ice several feet away. She has to open several escape routes so she has options if she comes up for air and finds a polar bear waiting for her.

I hear the familiar splash as her head appears in the hole in front of me. Lifting my camera again, I frame the scene with my wide-angle lens. Next to the furry, white newborn, the mother's wet, gray fur is sleek and shiny.

She looks at her pup as it calls out to her. Warm light of the morning sun falls over the scene as I take my first image.

With great effort, she pulls her body up onto the ice. I am lying only a few feet from the mother and her pup, and I can hear her breathe as the pup crawls over to her. The mother seal closes her eyes and relaxes on the snow as her baby begins to nurse, making contented suckling sounds.

My patience has paid off. After lying on the ice for hours, the seals have granted me a look into their lives, allowing me to be witness to this intimate moment between a mother and her pup. ⌒

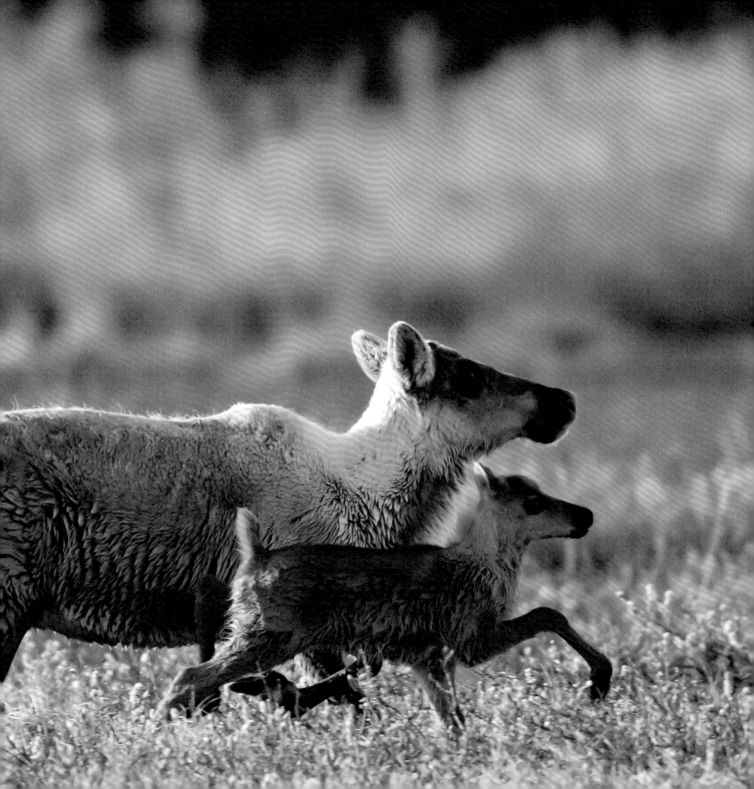

ARCTIC

CARIBOU

BY FLORIAN SCHULZ & EMIL HERRERA-SCHULZ

FS: Strange coughing and grunting noises enter my dreams, intermingling with sounds of the roaring of the river nearby. Emil and I are fast asleep in our tent, exhausted from our long journey to one of the most remote places in North America, the arctic coastal plains. My anxiety grows as I wonder if a wave of meltwater is rushing down to whisk us away. I wake up with a start and realize: It is the caribou!

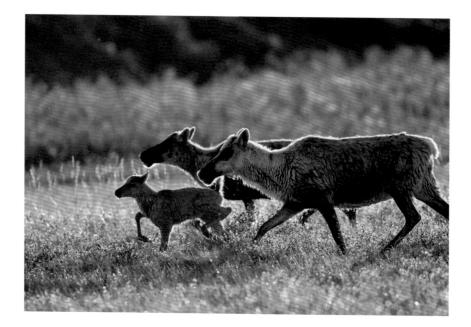

The Arctic is home to the largest mammal migration left in North America—a reminder of the vast buffalo herds that migrated across the continent until they were hunted almost to extinction in the late 1800s. Millions of caribou arrive on the arctic plains in summer in many large herds to have their young and to feed on the fresh green shoots of the tundra. After numerous expeditions in search of these wild creatures, we were at last witnessing the Western Arctic herd as it undertakes its astonishing 2,000-mile annual migration between northern Canada and the Alaskan coastal plains.

Emil and I scramble to collect camera gear. The sound of splashing water and grunting fill the air as a large group of caribou enters the river across from our camp. Slogging through the uneven terrain of the muskeg, we quickly make our way onto a nearby ridge. We arrive exhausted and drenched in sweat.

It is hard to express the joy that has overcome me. The landscape below is alive with thousands of caribou. I've waited for this moment for years. For me the caribou are a symbol of true wilderness. In the vastness of the Arctic, they pursue their ancient rhythm of migration

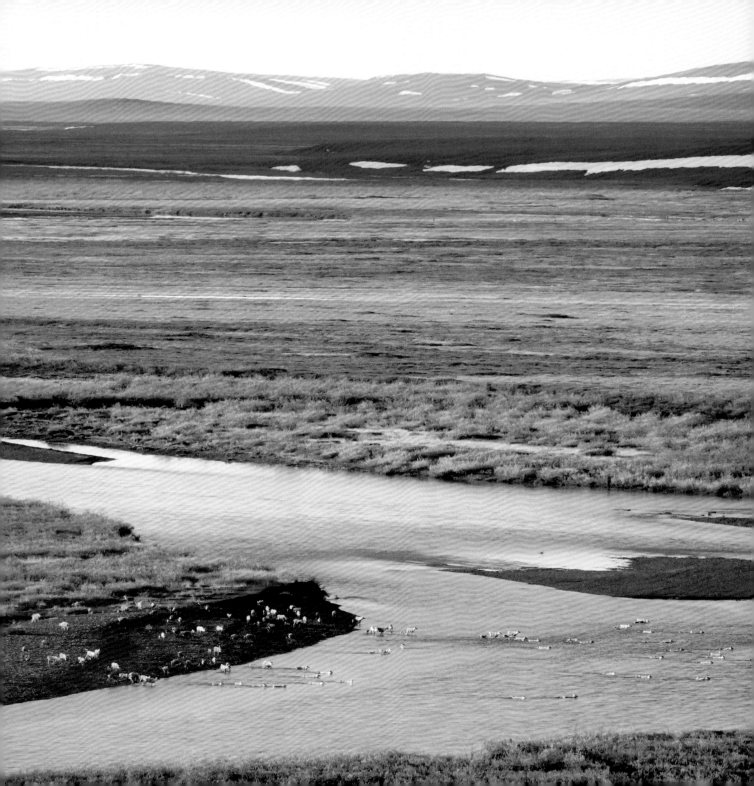

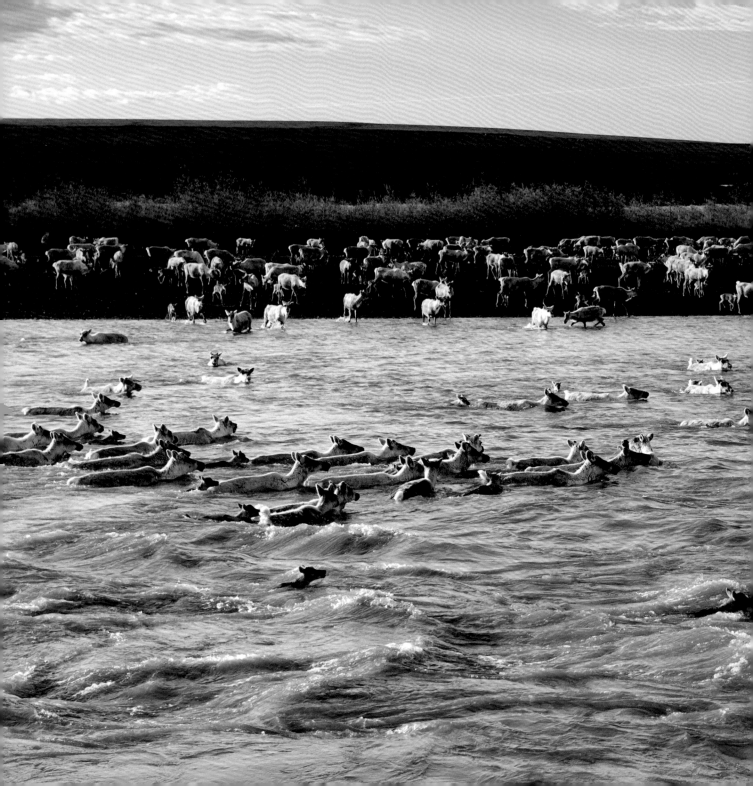

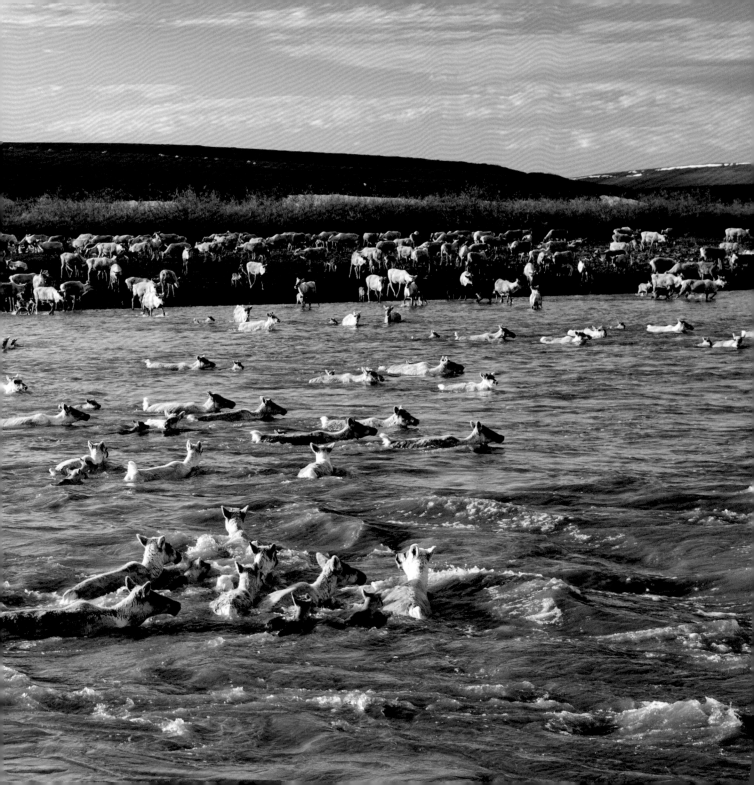

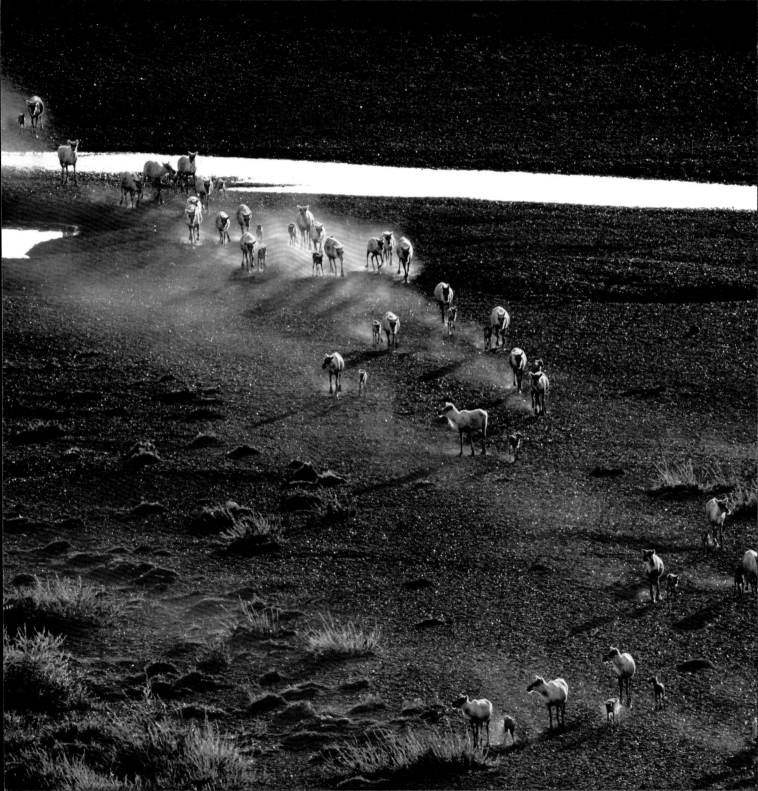

through the course of the seasons, just as they have for thousands of years.

EH-S: As Florian walks down closer to the river, I remain on the ridge with video camera and tripod to film from above. Florian quickly disappears among the golden grasses near where the caribou scamper out of the river. Through the viewfinder, I watch him photograph as ever more caribou arrive at the river and surround him. The sun lingers just above the horizon across the river toward the northeast, highlighting the caribou and the landscape with a fine rim of gold. In a depression at the edge of the river,

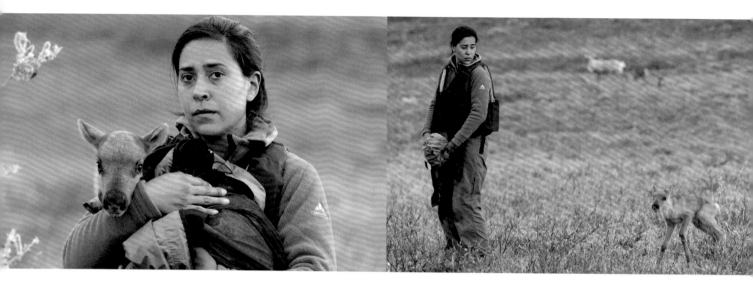

Florian is right in the middle of the caribou. Hundreds are climbing up the riverbank and pass within feet of his hiding spot. The air is filled with the caribou calls and coughs. In the chaos of the river crossing, mothers and calves get separated. Eyes bloodshot and filled with panic, mothers and calves look around for each other.

It is summer, and at this time of year and northern latitude, the sun never sets. We have been up for almost thirty hours. We return to our camp, hungry. While Florian puts some water on to boil in preparation for our meal, I grab my sound recording gear and head to the river. Beneath the thin layer of a camouflage blanket, I hunker down and wait. Headphones over my ears, I hear my

surroundings in stereo. Suddenly branches are cracking, hooves are trampling, and caribou are calling all around me. As the sounds become louder, I wonder if the animals might run over me.

FS: It has been a while and I wonder where Emil is. I see her running toward me from the river, and I can tell something is wrong.

Out of breath, she shouts, "Florian, I found a lost caribou calf—we need to rescue it!" I look at her with compassion, not sure what we can do. But she insists on leading me to the spot, and quickly explains that the mother is still nearby, running back and forth, calling for

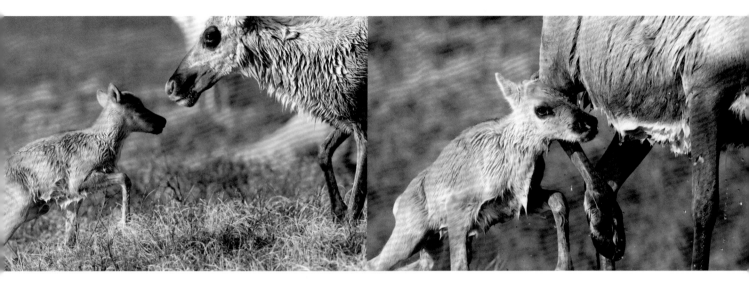

her calf. Willow branches whip against my face as we hurry through the brush.

When we reach the calf, it doesn't move as I appear above the trench where it has fallen. It is wet, cold, and shivering—and by this time, without energy to even call for its mother. As I look over to the frantic mother caribou beyond the willows, I understand what Emil is thinking. I pull off my jacket, kneel down and pick up the little caribou, and pass it into Emil's arms.

EH-S: With its last energy, the little calf kicks as Florian passes it over to me. I gently hug the calf and bring its legs together to make it feel snug and warm. Its fast-beating heart pumping against my chest begins to slow. I walk over to where the mother caribou is running in circles, calling her baby. As I place the calf on the ground, I feel its little snout pushing between my jacket and ribs, searching for milk. My heart melts at this expression of trust from this little calf. I get up and walk away, but it follows right behind me! The little guy is confused, and I look over to Florian.

Then suddenly, the call of the mother reaches the calf, and it turns toward her. On its long legs, the calf runs over to the cow, and both touch noses, recognizing their smells. With relief and joy, we watch cow and calf hurry together over the hill, to catch up with the rest of the migrating caribou as they continue their long journey. ∼

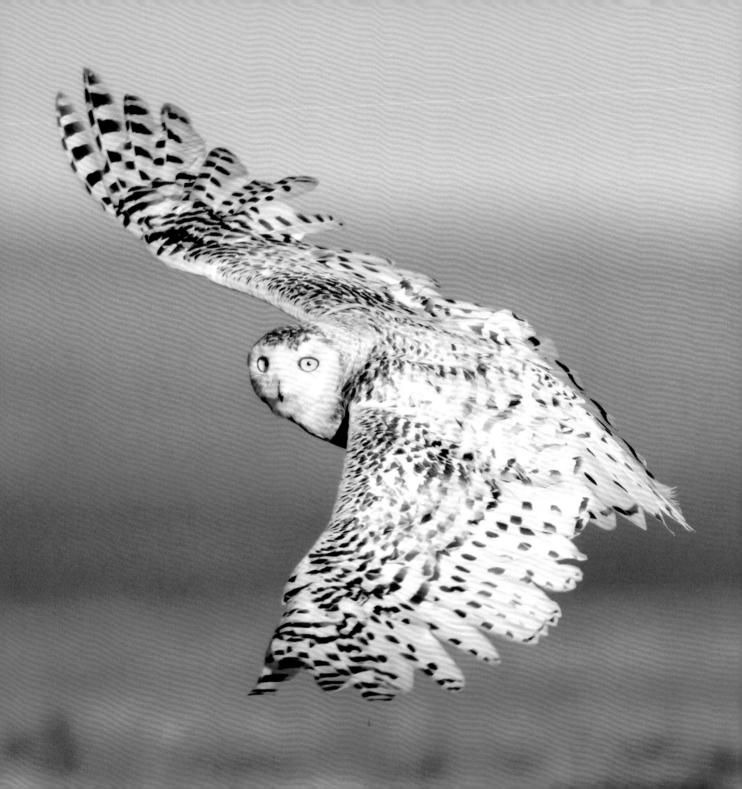

SNOWY OWLS

BY EMIL HERRERA-SCHULZ

We came to the North Slope of Alaska in search of a fascinating creature, one of the largest birds that nest only at ground level in the openness of the flat arctic tundra. Its plumage is pure white and its eyes have the intense yellow glow of the sun. We are in the land of the snowy owl.

I have seen these owls before from a distance. Today, I am just a few yards away from a nest of chicks awaiting the return of their parents. As I sit

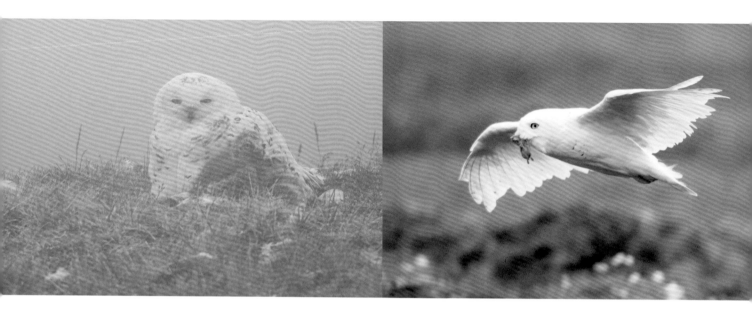

quietly inside a blind in the middle of the Alaskan arctic tundra, birdcalls fill the air around me. The windows of the blind are small, so I listen intently to sense what is happening outside. Florian is also waiting patiently— listening, and dozing.

Snowy owls have little time to breed and rear their young. In the relatively brief arctic summer season, feeding hungry chicks is an intense activity for the adult birds. Usually it is the male that provides for the nesting mother and chicks. But when chicks grow hungry and the male is absent, the female will risk leaving her young to search for food.

A cool, gray fog settles around us and the adults have not returned. The chicks huddle together to stay warm. I keep my eyes on the nest but stay alert, hoping to hear the call of the male. Suddenly, we make out a ghostly figure sitting motionless on top of a rise in the tundra. Then, effortlessly, gliding over the grass with wings fully extended, an owl quietly approaches the nest. Its piercing yellow eyes are focused on the nest. The female has returned.

With a purring sound, she calls to her excited chicks. Fluffing her plumage, the mother owl arranges herself around her young to keep them warm. Then she settles

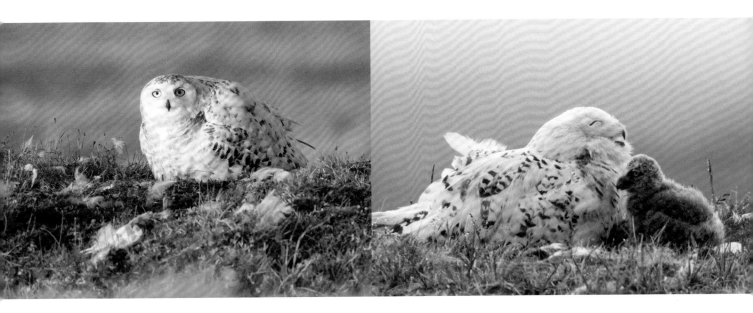

down, and before closing her eyes, she sends out a moaning call to her partner.

A few days ago, I helped owl researcher Denver Holt count lemmings around snowy owl nests. As head of Montana's Owl Research Institute, Mr. Holt has provided important knowledge about the biology of this species for over twenty years. Besides lemmings, the primary food of snowy owls, the owls also prey on weasels and foxes, and will even feed on other birds, including jaegers, eiders, and gulls.

Owls are powerful hunters. Diving from the sky with sharp talons outstretched, they can even drive away caribou that wander too close to their young. Their plumage insulates them as effectively as the fur of an arctic fox, and they can endure blasting winds and extreme temperatures of −40°F during the long, cold winter months.

The call of a jaeger catches my attention. The fog is dissipating, and we are able to see farther into the distance as the midnight sun shines over the nest. Between the wings of the female we see small, gray, fluffy owlets that have just awakened from a nap, and their beaks are wide open for food. The female cleans her feathers, and then uses her beak to gently inspect the fluffy down of her chicks.

Suddenly I see movement over the tundra. The male is making his way back, and I notice something hanging

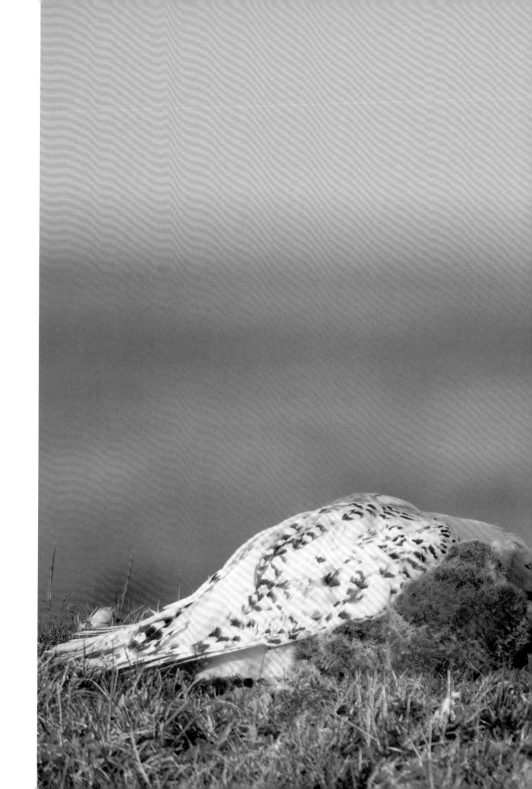

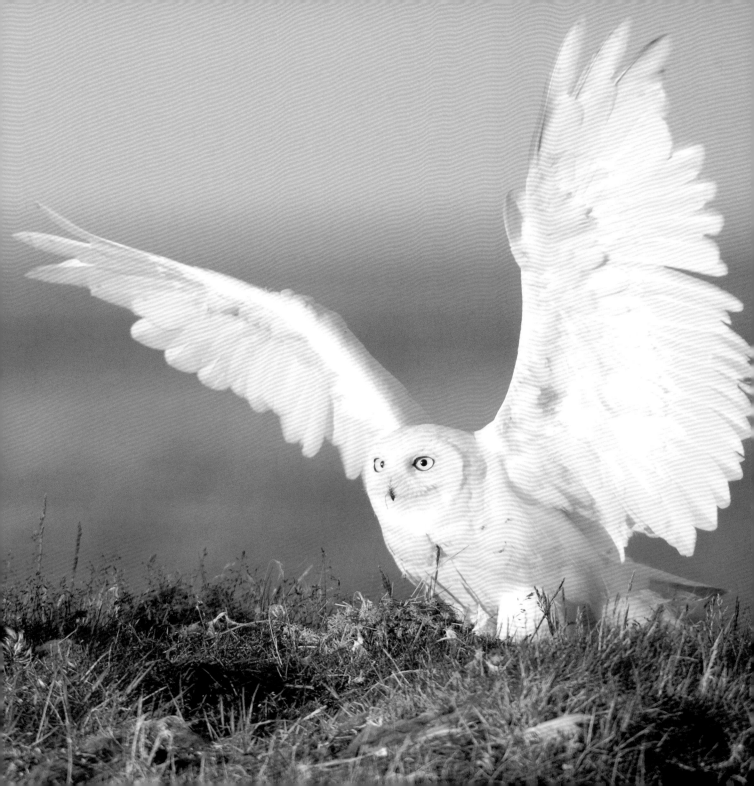

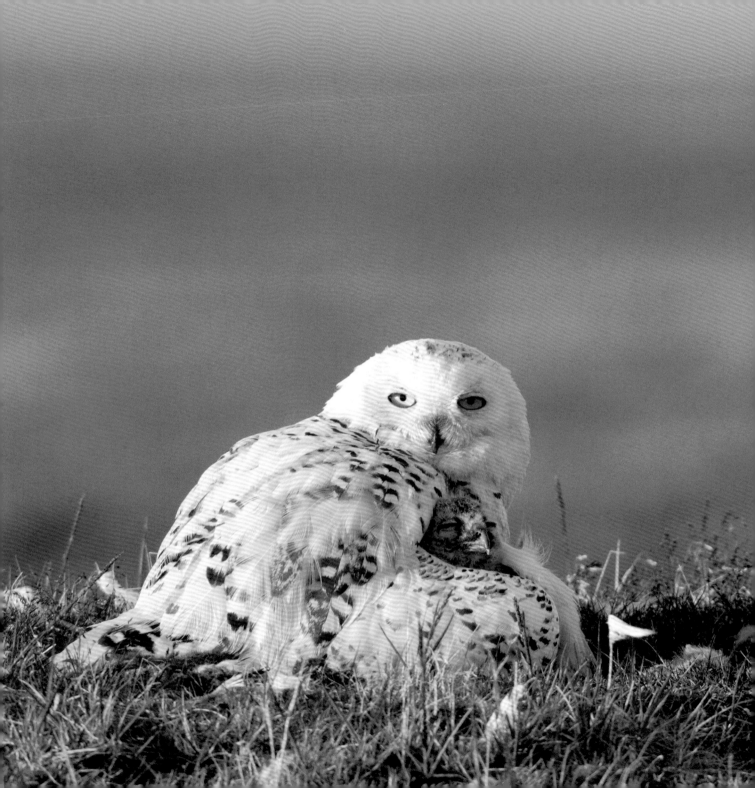

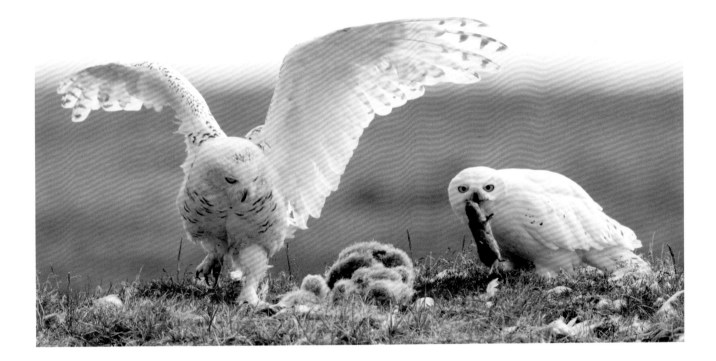

from his beak: a lemming. After twenty hours of waiting, Florian readies his camera. The owl is in front of our blind, hovering above the nest with wings spread. There is joy in Florian's eyes, as I hear the clicking of his camera.

The male is completely white, with hardly a single brown spot, and the female has scattered brown spots and bars. We are astounded by the beauty of these amazing animals. As the male lands and takes a few steps toward the chicks, one of the larger owlets jumps for the fresh meal. The male offers the lemming to the chick, which unsuccessfully tries to swallow the entire rodent. The female takes over the feeding ritual, dissecting the lemming into little pieces and offering them directly to the downy chicks.

Soon the male leaves to do what it does best: hunting. It will be a long wait before the male returns with another hard-earned prize. ◠

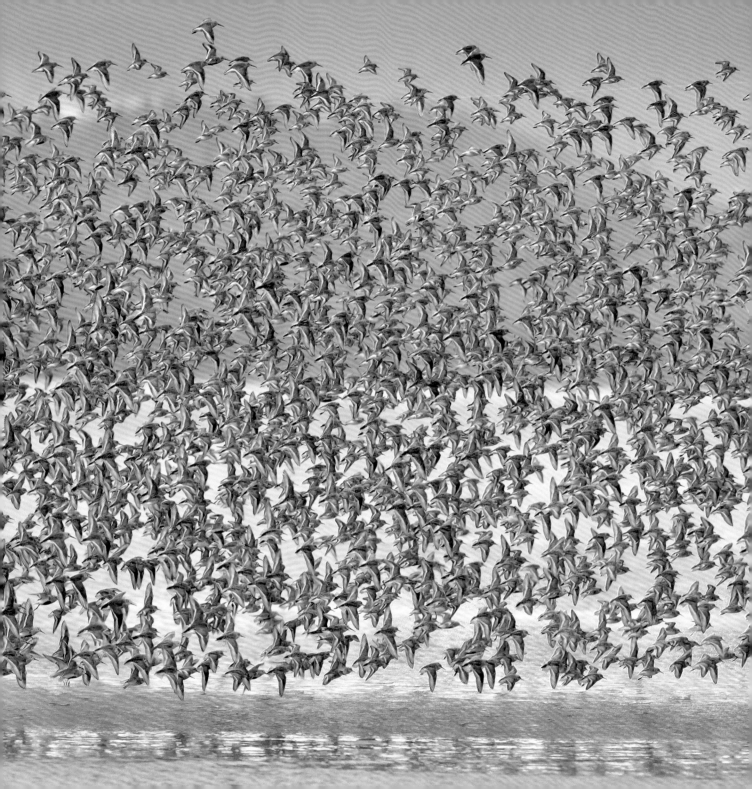

ARCTIC

MIGRATING BIRDS

BY FLORIAN SCHULZ

Millions of wings cut through the air, resembling the flutter of leaves in a vast forest blown by wind. Countless birds drop from the sky to land, so thick that the mountains on the other side of the bay disappear behind a curtain of feathers.

Over eight million birds make this annual stop at Prince William Sound, Alaska, to build up their fat reserves before they fly the final leg of their journey to the arctic plains. These birds represent only a

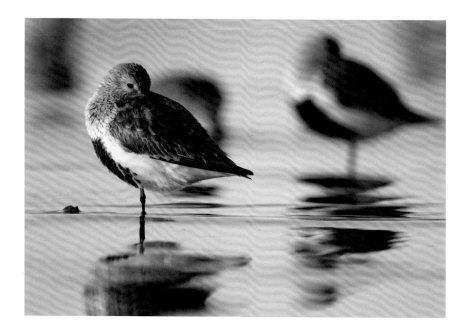

fraction of the many millions that will arrive from all corners of the globe, returning to their ancestral nesting grounds in summer. The arctic plains have an abundance of wetlands, and are ideal habitat for shorebirds, geese, ducks, and loons. The arctic summer is short, but the twenty-four hours of daylight create a rich environment for breeding and raising young birds.

One particular bird—the arctic tern—makes an epic round-trip of 24,000 miles from Antarctica all the way to the Arctic to nest and then back again, drawn by the warm climate and food availability at the poles as the earth shifts on its axis with the seasons. Emil and I have encountered this elegant seabird in many places beyond the Arctic Circle, where they breed and nest on gravel beaches along the ocean. They are fearless, and with sharp cries attack anything that nears their nest. To successfully rear their chicks, they nest in colonies to better defend themselves against intruders that include

◄◄ Migrating shorebirds, Alaska.　▲ Dunlin sandpipers, Cordova, Alaska.　▶ Mother arctic tern and chick, Beaufort Sea, Canada.

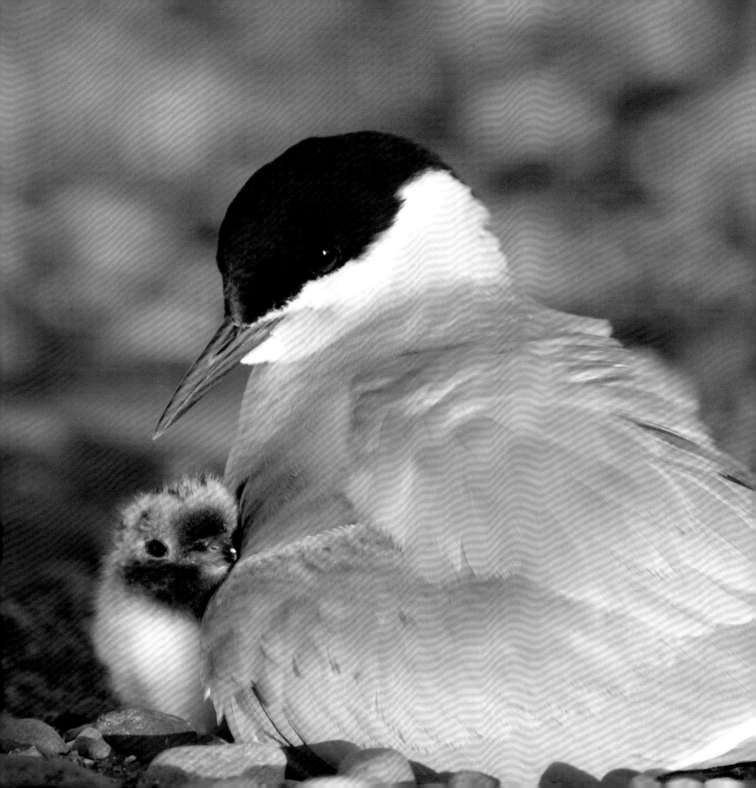

arctic foxes, jaegers, and even an occasional hungry polar bear.

In early July, we watch as the arctic tern chicks hatch from their carefully concealed gravel-colored eggs, at the very edge of the sea. The puffy little plume-balls find shelter under the mother's wing, while the male is busy catching small fish in the nearby ocean to feed the young family.

During the same time, the eggs of countless shorebirds hatch, including golden plovers, and upland, western, and dunlin sandpipers. Little furry chicks run across the tundra and then crouch down at any sign of danger, protected by their camouflaging color.

The young birds grow quickly in the arctic summer, fueled by the profuse insect and sea life. Huge flocks gather along the ocean shore and on tundra lakes, and soon shorter days will signal that it is time once again to head south. ⌒

▶ Peregrine falcon, North Slope, Alaska

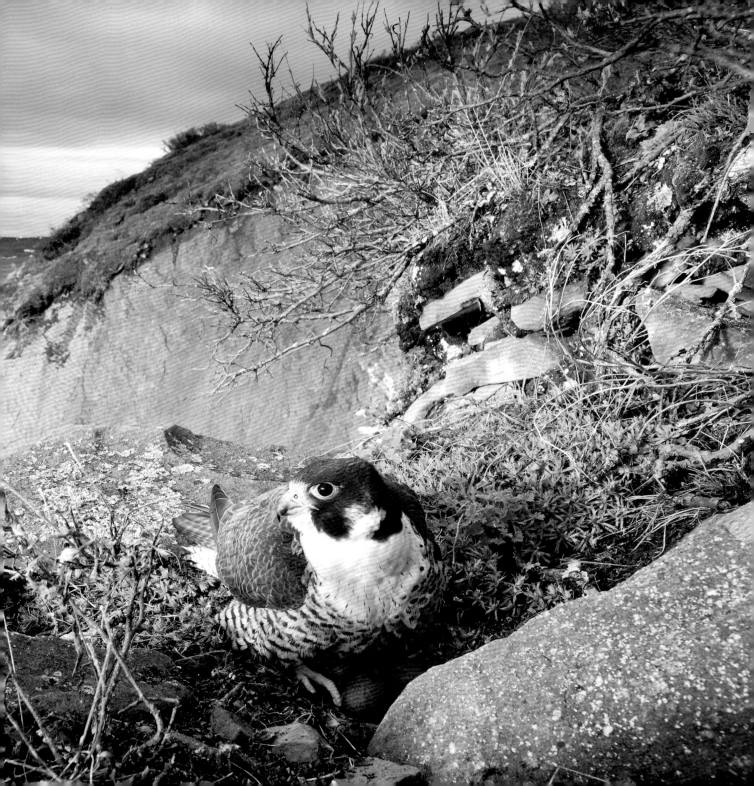

**An Interview with
GREG MacGILLIVRAY and
SHAUN MacGILLIVRAY,
Director and Producer
of *TO THE ARCTIC***

What surprised you the most
about filming in the Arctic?

GREG: The discovery that polar
bear mothers have the hardest job
on Earth, and the job is getting
harder every day. I was so amazed
and moved by the tenacity of the
mother bear that let us follow
her and her two cubs for nearly a
week. Everything she has to do to
keep herself and her cubs alive is
now much more difficult because
of warming temperatures. She
doesn't have as many months
to hunt because her hunting
grounds, the sea ice platforms,
are melting earlier each year. And
as the ice floes shrink, she and
other polar bears must occupy a
smaller location, meaning there's
extra competition for territory and
food. And yet she never gives up.
She's completely committed to
her cubs' well-being and safety,
twenty-four hours a day.

SHAUN: Audiences who see
our film on the immense IMAX
screens will feel transported.
They will get that same sense of
wonder and appreciation for this
incredible environment that we
were lucky enough to experience
firsthand over the past five years.

You've sent IMAX camera crews
to the top of Mount Everest and
all around the world. How did the
Arctic challenge your film team?

GREG: In the Arctic, we were
filming wildlife, which is very
difficult to film, especially in such
harsh conditions. There is a lot
of waiting and searching for the
animals, and because we want
to capture a variety of animal
behaviors, that takes even longer.
We were in the field for *To The
Arctic* for eight months, much
longer than for any of our other
films, including *Everest*.

Clockwise from upper left: The MacGillivray
Freeman Films production crew used a
103-foot icebreaker, the *Havsel*, as their
home base while on location for twenty-
two days in the archipelago of Svalbard,
Norway. The icebreaker gave the film
crew special access to the region's polar
bears that hunt seals all summer long on
the sea ice platforms, called ice floes.
Unique aerial views photographed from
the *Havsel*'s mast reveal a great expanse
of arctic seas and the recent changes in
sea ice density. The film crew traveled to
within nine degrees of the North Pole.
To The Arctic film director Greg MacGillivray
(in orange jacket) and director of
photography Brad Ohlund also used a
small skiff to get even closer to the bears.
"We were in such an exquisite, remote
place, it felt like being at the end of the
world," observed MacGillivray.

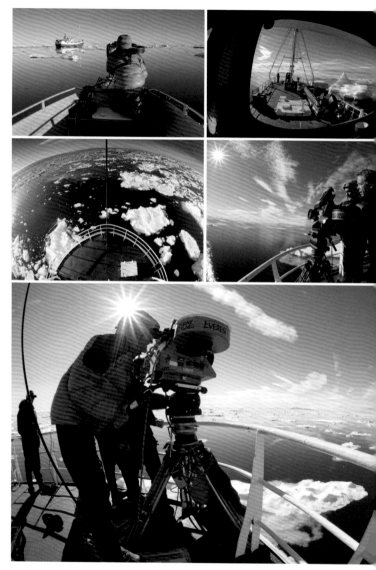

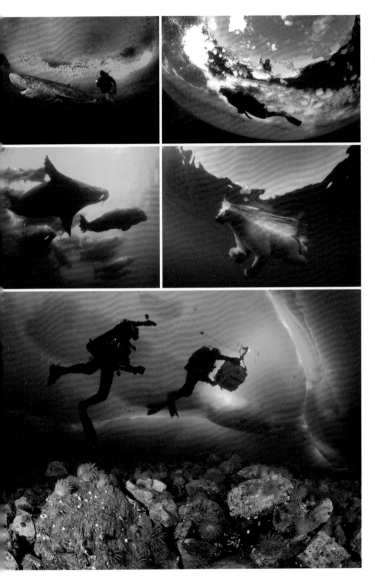

Diving under the ice in extreme temperatures with an IMAX camera must be extremely difficult. How did you get shots of the polar bears swimming underwater?

GREG: Bob Cranston is a brave underwater cinematographer who has photographed alligators, great white sharks, venomous snakes, and now, the fiercest predator of all—polar bears. He invented a way to shoot them by diving below them, then waiting for the bear's natural curiosity to cause them to investigate our cameras. If they came too close for comfort, Bob would quickly sink down into deeper water. Polar bears don't like to dive too deep—the deepest we saw a bear dive was about twenty feet—so Bob felt relatively safe as long as he was in deep enough water.

SHAUN: Because of the extreme water temperatures, which were below freezing, Bob's longest dive under the ice was forty-five minutes. Any longer and his hands would have become completely frozen.

What is your film's take-home message for audiences?

GREG: Everyone knows that the planet is changing, but they don't know that the Arctic is changing three times faster. For the glaciers, the ice cap, the animals, and the Native people, these changes are bringing hardship. Can we help? Yes, we can. But first, more people have to become aware of what's happening. That's where our film and this book come in. If enough people fall in love with the Arctic and support conservation efforts, we can make a difference.

SHAUN: We've also started the One World One Ocean campaign (www.OneWorldOneOcean.org), with a goal to reach and engage millions of individuals through films like *To The Arctic*, television

Clockwise from upper left: The diversity of Arctic marine wildlife is on full display in *To The Arctic*. A Greenland shark, native to the north Atlantic Ocean near Greenland and Iceland, surprised the underwater film crew with a visit, giving cameraman Bob Cranston the opportunity to capture the first-ever 70mm images of this unique marine creature. Cameraman Adam Ravetch looks for algae beneath the water's surface in Arctic Bay, Canada; Inuit guide Simon Qamanirq can be seen above standing on the edge of the ice floe. Polar bears have a surprising grace when swimming underwater. They are the only bears with a thick layer of blubber, which insulates them from the frigid Arctic Ocean. *To The Arctic* cameraman Bob Cranston and filmmaker Adam Ravetch are photographed by Dale Sanders as they maneuver the giant IMAX camera in Arctic Bay, Canada, in water literally as cold as ice. The salt content allows it to remain liquid, even though the water temperature is below freezing. In a kind of comical walrus traffic jam, an entire walrus herd swims together in a tight swirling knot. Walruses alternate their time between foraging for clams in the icy waters and basking for warmth on the rocks and floating ice floes.

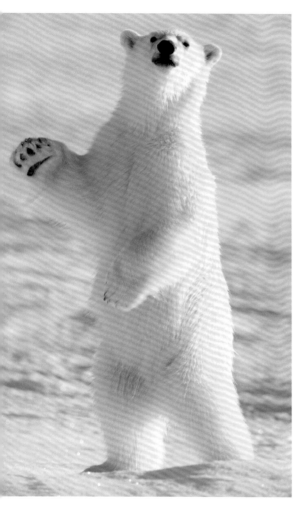

programs, online initiatives, and grassroots education programs— all designed to motivate and empower people to become part of a movement to restore and protect our oceans, including the Arctic Ocean. We are in a unique position to build this community because of the reach of our films, which play at more than two hundred IMAX theatres and other giant-screen cinemas in thirty-two countries. Our hope is that once we engage people emotionally through our films, they'll want to make the social changes necessary to heal our oceans. We can all make a difference with small simple decisions and actions in our daily lives.

How do you compare/contrast Florian Schulz's still photography with what you were trying to accomplish as filmmakers?

GREG: Florian is the rare still photographer who's passionate about doing something better than anyone has done it before.That's why he fit in so well with our team and got such incredible shots.

SHAUN: Florian knows how to get that one perfect still image that captures the essence of a place or an animal.

Photo-essay book *TO THE ARCTIC*

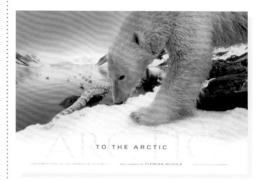

FLORIAN SCHULZ accompanied the MacGillivray Freeman Film team on several trips to the Arctic and published this large-format photo-essay book, *TO THE ARCTIC*. This book and *JOURNEY TO THE ARCTIC* are the official companion books to the film. *TO THE ARCTIC* is 212 pages, 15 inches x 10 inches, 200 images, hardbound: $45. Foreword by Sylvia Earle and preface by Greg MacGillivray.

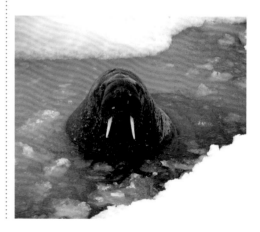

WARNER BROS. PICTURES AND IMAX FILMED ENTERTAINMENT PRESENT A MacGILLIVRAY FREEMAN FILM "TO THE ARCTIC" A ONE WORLD ONE OCEAN PRESENTATION NARRATED BY MERYL STREEP MUSICAL SCORE BY STEVE WOOD SONGS BY PAUL McCARTNEY EDITED BY STEPHEN JUDSON WRITTEN BY STEPHEN JUDSON PRODUCED BY SHAUN MacGILLIVRAY DIRECTED BY GREG MacGILLIVRAY

IMAX MACGILLIVRAY FREEMAN FILMS **G** GENERAL AUDIENCES All Ages Admitted www.imax.com/tothearctic Photos: © 2012 Florian Schulz WARNER BROS. PICTURES ©2012 Warner Bros. Ent. All Rights Reserved.

ABOUT THE AUTHORS

FLORIAN SCHULZ is a German-born, award-winning wildlife photographer who is dedicated to preserving wild environments. His passion for wilderness has taken him to remote locations around the globe, where he captures inspiring images of wildlife. He has received numerous international awards for his photography including Environmental Photographer of the Year. He has published two books with Braided River: *Yellowstone to Yukon: Freedom to Roam*, and *To The Arctic*, the companion book to the film *To The Arctic*. His work has been featured in international magazines including *National Geographic*, *GEO*, and *BBC Wildlife*. He is the youngest founding member of the International League of Conservation Photographers, and his work has been presented in important venues such as World Wilderness Congresses and the National Geographic Explorers Hall. The photographs in this book came from expeditions he undertook in the Arctic over the course of six years. www.VisionsoftheWild.com

EMIL HERRERA-SCHULZ has explored the western states of North America and the circumpolar Arctic with her husband, helping to photographically document the richness of these unique ecosystems. A native of Mexico, her curiosity about the natural world and passion to document untouched wilderness lead her to remote locations where she captures video footage and sound recordings. She blends her work with Florian's images to create powerful conservation and story-telling multimedia productions that support environmental campaigns.

GREG MacGILLIVRAY is an Academy Award–nominated film director and cinematographer whose production company, MacGillivray Freeman Films, has produced more than thirty films for IMAX theatres and other giant-screen cinemas. The company is the only documentary team in cinema history to reach the $1 billion box office benchmark. With his wife, Barbara, he launched the multimedia One World One Ocean Foundation to drive awareness and take action on behalf of the world's oceans. www.OneWorldOneOcean.org

BRAIDED RIVER

An imprint of THE MOUNTAINEERS BOOKS
1001 SW Klickitat Way, Suite 201, Seattle, WA 98134

© 2012, Warner Bros. Entertainment Inc.

TO THE ARCTIC and all related characters and elements are trademarks of and © Warner Bros. Entertainment Inc.

IMAX® is a registered trademark of IMAX Corporation.

Zodiac® is a registered trademark of Zodiac Marine & Pool Group.

Text © 2012 by Florian Schulz and Emil Herrera-Schulz Preface © 2012 Warner Bros. Entertainment Inc. Written by Greg MacGillivray

Photographs © 2012 Florian Schulz with the exception of page 76, 2nd row, 1st photo; page 77, 1st row both photos, 2nd row both photos © 2011 Warner Bros. Entertainment Inc. Photos: MacGillivray Freeman Films; and bottom photo © 2011 Warner Bros. Entertainment Inc. Photo: Dale Sanders

BRAIDED RIVER
Publisher: Helen Cherullo
Cover and Book Design: Elizabeth M. Watson, Watson Graphics
Photo Editor: Emil Herrera-Schulz
Editor: Ellen Wheat
Managing Editor: Margaret Sullivan
Braided River Development and Communications: Laura Waltner
Map: John Barnett/4 Eyes Design

For more information on this book, partners, events, and how you can make a difference, please visit www.WelcomeToTheArctic.org

For more information on the film *To The Arctic*, please visit www.imax.com/tothearctic

Library of Congress Cataloging-in-Publication Data on file

ISBN: 978-1-59485-488-0

Printed in China by C & C Printing

Photos. Front cover: Mother polar bear and her cub, Baffin Island, Canada. Back cover: Ringed seal pup, Svalbard, Norway.

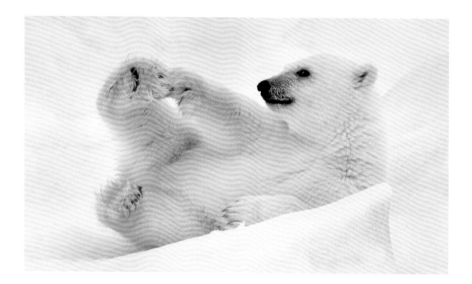